WHERE CLEVELAND PLAYED

SPORTS SHRINES FROM LEAGUE PARK TO THE COLISEUM

MORRIS ECKHOUSE & GREG CROUSE

Published by The History Press
Charleston, SC 29403
www.historypress.net

Copyright © 2010 by Morris Eckhouse and Greg Crouse
All rights reserved

Cover images: *Front cover, top, left to right*: Authors' collection; Courtesy the Walter C. Leedy Postcard Collection, www.ClevelandMemory.org; Courtesy Jeff Suntala; Authors' collection. *Front cover, bottom:* Courtesy the Rick Bradley Postcard Collection. *Back cover:* all images courtesy the Cleveland Press Collection, Cleveland State University Special Collections.

First published 2010

Manufactured in the United States

ISBN 978.1.59629.270.3

Library of Congress Cataloging-in-Publication Data

Eckhouse, Morris.
Where Cleveland played : sports shrines from League Park to the Coliseum / Morris Eckhouse and Greg Crouse.
p. cm.
Includes bibliographical references.
ISBN 978-1-59629-270-3
1. Sports--Ohio--Cleveland. 2. Sports facilities--Ohio--Cleveland. I. Crouse, Greg. II. Title.
GV584.5.C58E27 2010
796.0977132--dc22
2010035215

Notice: The information in this book is true and complete to the best of our knowledge. It is offered without guarantee on the part of the authors or The History Press. The authors and The History Press disclaim all liability in connection with the use of this book.

All rights reserved. No part of this book may be reproduced or transmitted in any form whatsoever without prior written permission from the publisher except in the case of brief quotations embodied in critical articles and reviews.

To all of my friends and family members who have enjoyed games with me. If you think I mean you, I do. And to my nephew Max. I hope you find as much enjoyment from something as I have from baseball.

–GC

To Allen Eckhouse for his twenty-first birthday (a little late), Maria Eckhouse for our twenty-fifth anniversary (a little early), Ellen Eckhouse (proprietor of The Village Bookstore), Joanne Valenti for taking time away from Turner Classic Movies to read this and the memory of Eleanor Eckhouse, Melvin Eckhouse and Tony Valenti.

–ME

Contents

Foreword by Joe Tait 7
Acknowledgements 9
Introduction 11

League Park 15
Cleveland Arena 35
The Coliseum 59
Cleveland Municipal Stadium 87

Conclusion 133
Bibliography 139
About the Authors 143

Foreword

In this much too fast-paced life of ours, some of the foundations of living are either forgotten or ignored. This is certainly true in the world of sports in general and in Cleveland in particular.

Personally, I have had the good fortune to live in northeastern Ohio for more than forty years. In that time, I have worked in three of the four venues covered in this book and have stood in the remains of the other with pitcher Mel Harder, who recreated for me in the course of one day the structure of League Park.

This book, lovingly crafted by the authors, will do the same for the reader, who will be drawn into the days gone by, where some of the greatest names in Cleveland sports history gave fans moments to remember. *Where Cleveland Played: Sports Shrines from League Park to the Coliseum* is a work of art unto itself. Names and games are presented to the readers in a way that will help them understand why those of us who can remember embrace the book as a travelogue to where we have been. We are reminded in facts and figures of what happen in these venues—when and why.

For the young fans who may have more interest in a "fantasy game" than the real thing, I urge you to take the time and effort to read this book and discover that the realities of the past are much more intriguing than the fantasy of the present. League Park is almost rubble. The Cleveland Arena and the Coliseum are totally gone. Municipal Stadium has given way to a new edifice on the lakefront. Now, through the magic of the printed words of Morris Eckhouse and Greg Crouse, Cy Young will pitch again in League

Foreword

Park, Johnny Bower will defend the Barons' goal at the Cleveland Arena, World B. Free will fill the hoops at the Coliseum and Jim Brown will rumble into the end zone. Highlights and lowlights are recalled, and there were plenty of both.

I urge you to take the time to both learn and enjoy.

<div align="right">–Joe Tait, "The Voice of Cleveland"</div>

Acknowledgements

Joe Gartrell of The History Press was enthusiastic about this project from its outset and steered it efficiently to completion. Thanks to Joe and also to Project Editor Ryan Finn and everyone else at The History Press who participated in the project.

Lynn M. Duchez Bycko, MA, the special collections associate at Cleveland State University's Michael Schwartz Library, was always pleasant and helpful in handling all of our requests.

The CSU library with its Cleveland Press Collection is one of many wonderful resources for sports fans, researchers and scholars. Cleveland may well be "the best location in the nation" for sports research.

Cleveland Public Library with its microfilm room was a major asset in the completion of this book. The extended CLEVENET consortium of thirty-one library systems in northeast Ohio, the Akron-Summit County Public Library system and the Cuyahoga County Public Library system are a blessing to the greater Cleveland area.

There are many stories worth telling about Cleveland's lost sports shrines. The books of Jim Toman (Cleveland Municipal Stadium), Russ Schneider (Cleveland Indians) and Gene Kiczek (hockey in Cleveland) have preserved large chunks of Cleveland sports history for generations to come. Stories of specific players, teams and seasons are recounted in numerous wonderful books. Thanks to all of the writers who have taken the time and effort to preserve and perpetuate these stories.

Acknowledgements

We have both listened to Joe Tait for most of our lives. We are honored by his eloquent foreword and his kind words. Congratulations to Joe on his receipt of the 2010 Curt Gowdy Media Award from the Naismith Memorial Basketball Hall of Fame, the latest of his many well-deserved honors for sportscasting excellence.

Thanks to Jeff Suntala for graciously allowing us to use his beautiful illustration of League Park. Visit Jeff's website, www.suntala.com, to view his other great artwork and for ordering information.

Thanks to the collaborative effort of OnCell, October Productions and the Baseball Heritage Museum, a companion audio tour to the book can be found at www.magicalbaseball.com or by calling the audio tour at 216-912-7087.

The following people know why they are listed. If not, just ask us.

Ken Barth
Tanya and Rick Bradley
Bill Bryan
Maria and Allen Eckhouse
Storm Miller
Joe Pryweller
Fred Schuld
Brad Sullivan
John Zajc

Introduction

For many of us, League Park, Cleveland Municipal Stadium, Cleveland Arena and the Coliseum were homes away from home. We knew the quickest ways in and out, the closest concession stands and restrooms and the best parking spots. Even when we weren't there, we were still there thanks to our friendly radio announcers like Tom Manning, Jack Graney, Jimmy Dudley, Harry Jones, Bob Neal, Gib Shanley, Jim Graner, Ken Coleman, Herb Score, Joe Tait, Steve Albert, Lee Hamilton, Nev Chandler, Casey Coleman and Tom Hamilton.

League Park is gone now. You can stand at the corner of East 66th and Lexington Avenue and, with a little imagination, envision the first game there in 1891, the Addie Joss benefit game, the 1920 World Series and any number of events. You can stand on the field in the footsteps of Joe Jackson, Tris Speaker, Hal Trosky, Bill Wambsganss, Lou Boudreau and Bob Feller.

Walk down West 3rd Street toward Cleveland Browns Stadium. Others before you walked the same path to see Boudreau, Feller, Larry Doby, Sam McDowell, Lou Groza, Jim Brown and other sporting greats. Look inside the gate and see the hallowed ground where Otto Graham, Frank Robinson, Brian Sipe, Len Barker, Bernie Kosar and Carlos Baerga made history.

Take the RTA Health Line to the corner of Euclid Avenue and East 36th Street. Look at the Red Cross building. That's where Austin Carr broke in with the Cleveland Cavaliers, where legendary goalies Johnny Bower and Gerry Cheevers played for Cleveland. You'd never know it, would you?

Introduction

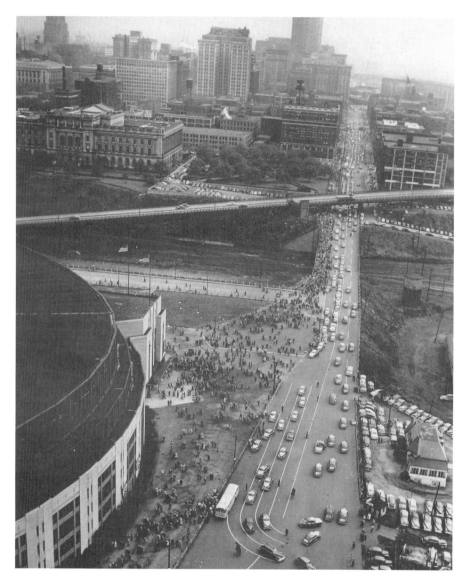

Fans streamed down West 3rd Street to the Stadium. Many would have taken the Rapid Transit to Terminal Tower and then headed north to the ballpark. *Courtesy the Cleveland Press Collection, Cleveland State University Special Collections.*

Drive out to the intersection of Interstate 271 and Ohio Route 303. In this pasture, Frank Sinatra performed and the "Miracle of Richfield" took place. "Bingo" Smith, Jim Chones, "Bucky" Buchanan, Dennis Maruk, World B. Free, Kai Haaskivi, Mark Price and Brad Daugherty thrilled fans there.

Introduction

If you ever went to any of these places, you'll have your own favorite memories of going to them by yourself or with others. You'll remember your route to the place. You'll remember the entrance and something about going to your seat. You may remember a sense of excitement or a sense of something special—or both.

As trends changed and these old homes turned tired and obsolete, they were physically replaced, but they live on in history and memory.

League Park

The 1891–1909 version of League Park helped establish baseball as an institution in Cleveland. For a time, though, it looked to be the site of the end of Cleveland's big-league baseball. The site was chosen by Frank Robison, owner of the National League Cleveland Spiders, because of its proximity to his trolley line. Before the wooden-built League Park opened on May 1, 1891, professional baseball had been played in Cleveland at the National Association Grounds on East Willson Avenue (later East 55th Street), at Kennard Street Park and between East 35th and East 39th Streets near the Robison trolley line. Games were also played at a variety of sites outside the Cleveland city limits to evade the blue laws that prohibited baseball on Sundays.

The Cleveland Spiders of the National League brought the Temple Cup series (a nineteenth-century equivalent of the World Series) to East 66th and Lexington three times and won the cup in 1895. Louis Sockalexis, the first recognizable Native American in Major League Baseball, played there for the Spiders. After Robison sent his best players to his other team in St. Louis, the Spiders had a horrific 1899 season and went out of business.

Thanks mostly to American League President Ban Johnson and local businessman Charles Somers, the financial "angel" of the league, Cleveland remained a home to Major League Baseball and became a charter member of the American League. The acquisition of Napoleon Lajoie in 1902 gave the new team credibility and a new nickname, the Naps. The Naps peaked in 1908, led by Lajoie and pitching sensation Addie Joss. With the

Where Cleveland Played

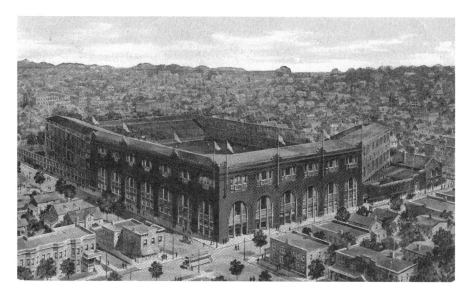

The steel, concrete and brick League Park was built following the 1909 season, replacing the old wooden structure and increasing the capacity to twenty-one thousand. *Courtesy the Rick Bradley Postcard Collection.*

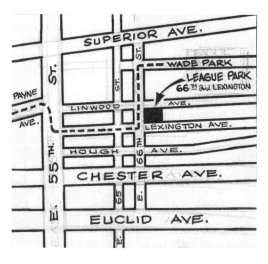

League Park was located in the Hough neighborhood east of downtown Cleveland, near four major roads: Euclid, Chester and Superior Avenues and East 55th Street. *Courtesy the Cleveland Press Collection, Cleveland State University Special Collections.*

pennant up for grabs, Joss pitched a perfect game at League Park on October 2, 1908, considered by many the greatest pitching performance of all time.

The League Park of 1891–1909 and the League Park of 1910–46 were as different as Cleveland Browns Stadium is from Cleveland Municipal Stadium. Both League Parks were located at the exact same place, but the second League Park ranked with Forbes Field in Pittsburgh and Shibe Park in Philadelphia as offering the best and most modern architecture in baseball.

Sports Shrines from League Park to the Coliseum

League Park was bounded by Lexington Avenue to the south, Linwood Avenue to the north, East 66th Street to the west and East 70th Street to the east (although the eastern boundary of the ballpark did not extend all the way to East 70th Street). It was built in the Hough neighborhood, an area bounded by Euclid Avenue to the south, Superior Avenue to the north, East 55th Street to the west and East 106th Street to the east. It was a predominantly white, middle-class community of single-family homes.

League Park's baseball dimensions were influenced by its location. Home plate was set near the corner of East 66th Street and Linwood, dictating a short distance down the right-field line and long distances to left field and center field. To compensate for the short distance to right field, a twenty-foot-tall wall topped with a twenty-five-foot screen was constructed. The ballpark was designed by Cleveland's Osborn Engineering Company.

The dimensions of the wooden-built League Park were 353 feet to left field, 409 to center, 445 to the right-center-field corner and 290 to right field. The one constant at the modernized League Park was the short distance

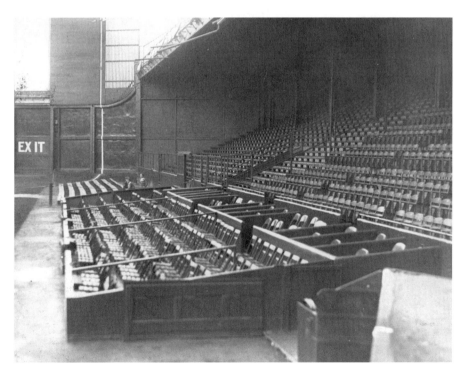

This view of the right-field box seats and grandstand shows League Park in 1930. *Courtesy the Cleveland Press Collection, Cleveland State University Special Collections.*

down the right-field line. Left field was increased to 375 feet from home plate, with center field 420 feet away. The deepest part of the new park, to the scoreboard left of center field, was 460 feet. Entrances were located at the corner of Lexington Avenue and East 66th Street (for grandstand or pavilion seating) and on Linwood Avenue (for the bleacherites).

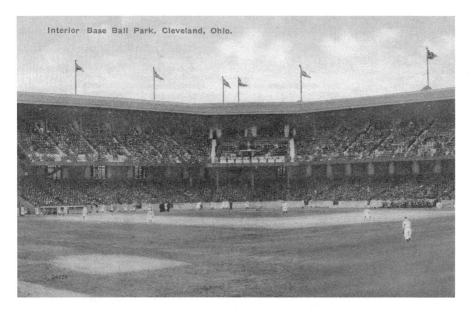

This page: The new League Park had more foul territory than its predecessor but still put baseball fans right on top of the action. *Courtesy the Rick Bradley Postcard Collection.*

Sports Shrines from League Park to the Coliseum

The League Park of concrete and steel opened on April 21, 1910, and Cy Young was awarded the starting assignment for Cleveland. When Young started the first game at the original League Park on May 1, 1891, he had begun that season with nine major league victories. He began the 1910 season with more than 490 wins on the way to a likely untouchable record of 511.

Young took the mound in a park that cost $300,000 to build and had a seating capacity of 21,000 (12,000 unobstructed by posts). There were 18,832 in attendance for the 1910 home opener. The Naps failed to score and lost, 5–0, to the Detroit Tigers.

Addie Joss was the pitching leader of the Naps, but tragedy befell Joss and the team when he died of tubercular meningitis at the age of thirty-one on April 14, 1911. An outpouring of sympathy for Joss and his surviving family led to a legendary baseball game that some consider the first all-star game. The Joss benefit game was scheduled at League Park on July 24, 1911, between the Naps and a team of baseball stars. Cleveland's *Plain Dealer* called it "the greatest array of players ever seen on one field."

Stars including Tris Speaker, Walter Johnson and Ty Cobb turned out in support of Addie Joss Day at League Park. Notice Cobb wearing a Cleveland uniform. *Authors' collection.*

League Park's version of the "knothole gang" peaks into the ballpark. If a ball came over the fence, they could return it and get inside the park. *Courtesy the Cleveland Press Collection, Cleveland State University Special Collections.*

E.S. Barnard, vice-president of the Naps, thought up the game. Future Hall of Famers Ty Cobb, Walter Johnson, Ed Walsh, Sam Crawford, Tris Speaker, Eddie Collins, Frank "Home Run" Baker and Bobby Wallace all answered the call. Cobb forgot his Detroit Tigers uniform and donned a Naps uniform for the game. Walsh, who was brilliant in defeat when Joss pitched his perfect game, offered to pitch for Cleveland against the stars.

Cleveland featured two of its own Hall of Famers, infielder Nap Lajoie and pitcher Cy Young. The amazing Young had won nineteen games for the Naps in 1909, nearly twenty years after pitching the first game at the old, wooden, League Park. "Shoeless" Joe Jackson and the outfielder later turned broadcaster Jack Graney also graced the Cleveland lineup.

The all-stars won the game, 5–3, before 15,272 fans at League Park. Hal Chase had three hits for the stars, while Speaker, Collins, Cobb and Clyde Milan had two hits each. The game took just one hour and thirty-two minutes and raised $12,931.60 for Mrs. Joss and her family.

Entering the 1920 season, the Cleveland Indians had yet to win a pennant. The '08 club, known then as the Naps, had come close at the old League Park but fell short of Detroit. It was the closest Somers would come to a World Series.

Lajoie left and Somers traded off Joe Jackson in 1915. In 1916, Somers sold the club to "Sunny" Jim Dunn. During his ownership, League Park would be known as Dunn Field, and his team would become known forever after as the Cleveland Indians. Dunn engineered a trade that brought Speaker,

Sports Shrines from League Park to the Coliseum

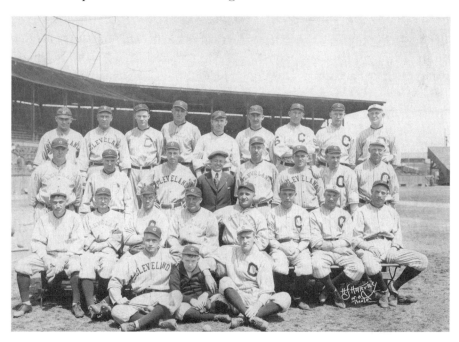

The 1919 Cleveland Indians finished second to the Chicago "Black Sox" in the American League pennant race. Tris Speaker (top row, second from left) became player-manager of the Tribe that season. *Courtesy the Cleveland Press Collection, Cleveland State University Special Collections.*

the great center fielder, from Boston's American League club to Cleveland. Gradually, the club worked its way into contention in the late teens.

When the club acquired Speaker in 1916, another pennant run was in the making. By 1920, with Speaker as player-manager, the popular Ray Chapman a star at shortstop and a talented pitching staff, the Indians started out well and battled for first place into August.

On August 15, 1920, the first-place Indians concluded a twenty-game home stand with a 5–0 win over the St. Louis Browns. It would be Ray Chapman's last home game. The Indians headed to New York.

A day later, on August 16 at the Polo Grounds, Chapman was fatally beaned by pitcher Carl Mays of the Yankees. Members of the Indians, and their fans, were devastated.

Harry Lunte initially replaced Chapman. Then Joe Sewell was promoted to Cleveland from New Orleans. The Indians remarkably overcame the death of Chapman to remain neck and neck with the White Sox and the Yankees, who were led by new slugging sensation George Herman "Babe" Ruth.

In late September, the 1919 American League champion White Sox invaded League Park and won two of three games to move within a half-game of first place amid growing suspicion that the Sox participated in a "fix" of the 1919 World Series against the Cincinnati Reds.

Days later, seven members of the 1920 White Sox were indicted by the Cook County, Illinois grand jury and charged with conspiring to "fix" the 1919 World Series. All seven players were quickly suspended. (The eighth of the "Eight Men Out," Chick Gandil, was no longer playing in the major leagues.) On October 2, the Indians clinched the American League pennant.

The 1920 World Series began in Brooklyn and then headed to League Park following three games at Ebbets Field, where Cleveland lost twice. On October 9, 1920, the Indians beat Wilbert Robinson's team, 5–1, and evened the best-of-nine series at two games each.

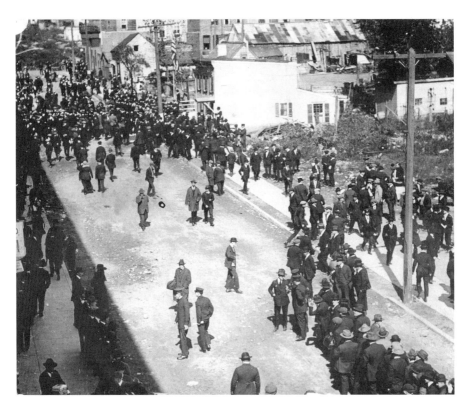

Fans mill about League Park during the 1920 World Series between Cleveland and Brooklyn. *Courtesy the Cleveland Press Collection, Cleveland State University Special Collections.*

Sports Shrines from League Park to the Coliseum

The next day, Jim Bagby took the hill for the Indians. After Bagby set down Brooklyn in the first inning, Cleveland's first three batters loaded the bases against pitcher Clarence Mitchell. Cleanup batter Elmer Smith followed with a home run, the first grand slam in the history of the World Series. Bagby himself made history at-bat in the fourth inning when he homered, the first home run ever hit by a pitcher in the World Series, into the temporary stands set up in front of the bleachers to enlarge League Park's capacity for the Fall Classic. The fifth game of the 1920 World Series will always be best remembered for the defensive play by second baseman Bill Wambsganss in the fifth inning. Pete Kilduff and Otto Miller had both singled when the pitcher, Mitchell, came to bat. Mitchell hit a line drive to Wamby's right, between him and second base. Wamby caught the line drive and ran to second base to double up Kilduff. He turned toward first only to see Miller standing in front of him and easily tagged the stunned runner for the third out of the inning. Wamby's unassisted triple play, the first and only in World Series history, capped Cleveland's 8–1 victory before 26,884 fans.

The following day, 27,194 fans filled League Park and saw Walter "Duster" Mails shut out Brooklyn, 1–0. On October 12, Stan Coveleski pitched his third complete game of the series. Cleveland defeated Brooklyn, 3–0, before 27,525 fans and won the 1920 World Series five games to two. The Indians had their first and only championship at League Park.

After the season, the Cleveland Baseball Company published *Dunn Field Pointers* to aid its patrons. It noted that "Payne Avenue and Wade Park [trolley] cars pass the main entrance to Dunn Field, which is located at the corner of East 66th Street and Lexington Avenue." It further noted ticket prices of $1.50 for box seats, $1.25 for reserved seats, $1.00 for the grandstand/general admission, $0.75 for pavilion admission and $0.50 for the bleachers (all prices included tax). Tickets were color-coded so fans could tell where their seats were.

There was plenty of excitement at League Park after the 1920 World Series and through 1946. Babe Ruth was in a league of his own among opposing players to visit Cleveland. Ruth reached his own milestone on August 11, 1929, by belting his five hundreth major league home run over the right-field fence and out onto Lexington Avenue against Willis Hudlin.

League Park was ill-equipped to compete in an automobile-dominated society. The new League Park was less than twenty years old, and already plans for bigger and better and newer were in the works. With a November 6, 1928 vote approving construction bonds for a lakefront stadium, the die was cast. The Indians continued to play at League Park as the team and city

Left: A 1943 view of the center-field scoreboard at League Park as the Indians played host to the Washington Senators. *Courtesy the Cleveland Press Collection, Cleveland State University Special Collections.*

Below: The right-field grandstands at League Park. The park is ready for opening day in 1930. *Courtesy the Cleveland Press Collection, Cleveland State University Special Collections.*

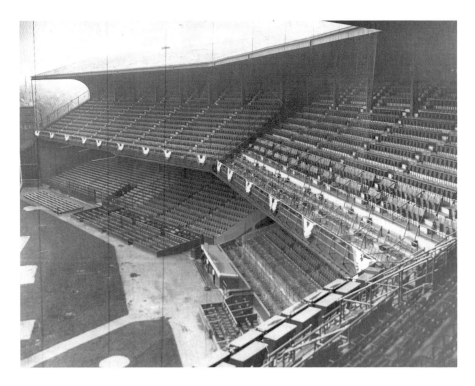

officials negotiated an arrangement for the team to play at the new stadium. In July 1932, the Indians left League Park for Cleveland Municipal Stadium.

League Park sat empty of Major League Baseball for the rest of 1932 and all of 1933. The Tribe suffered on the field and at the gate. So, in 1934, the Indians returned to League Park. For the next thirteen seasons, the team migrated between two homes. The Stadium was used for Sunday and holiday games, as well as night games starting in 1939. Lights never were installed at League Park.

When a young, hard-throwing right-handed pitcher came to town from Van Meter, Iowa, he came to League Park. Bob Feller's debut in Cleveland is the stuff of baseball myth. It came in 1936 on July 6 at League Park in an exhibition game against the St. Louis Cardinals, the legendary "Gashouse Gang" of Dizzy Dean and company. The seventeen-year-old Feller struck out eight Cardinals in just three innings. On September 13, Feller registered seventeen strikeouts, a new American League record, as the Indians beat the Philadelphia Athletics, 5–2.

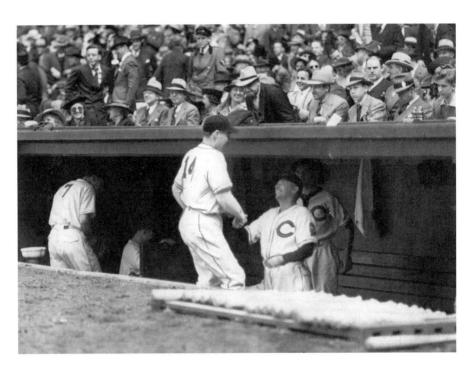

Manager Oscar Vitt greets Bob Feller in the Cleveland dugout. Vitt was at the center of the 1940 "Crybabies" controversy. *Courtesy the Cleveland Press Collection, Cleveland State University Special Collections.*

Like Tris Speaker before him, Bob Feller's arrival in Cleveland sparked a climb back toward the pennant. By 1940, led by third-year manager Oscar Vitt, pitchers Feller and Mel Harder, young shortstop Lou Boudreau and slugging first baseman Hal Trosky, the Indians were a clear challenger for the American League Championship.

The 1940 Cleveland Indians became known as "the Crybabies." Frustrated with Vitt's acerbic personality and constant carping, a group of twelve Tribe players went to owner Alva Bradley on June 13 to demand that he replace the manager. Bradley deferred action; the rebellion was discovered by newspaper reporters and made headlines throughout the baseball world the next day.

Vitt remained manager, and the Indians remained in the thick of the pennant race. Like the races of 1908 and 1920, the 1940 battle between the Indians and Detroit Tigers went right down to the wire, but the finish line was at Cleveland Municipal Stadium. From April to August, the Tribe continued to use both League Park and the Stadium for its home games. With a five-game winning streak in mid-August, the Indians were twenty-

The pennant-contending Indians of 1940 brought plenty of fans out to League Park. Attendance that year of 902,576 (League Park and Stadium combined) was Cleveland's highest since 1920. *Courtesy the Cleveland Press Collection, Cleveland State University Special Collections.*

five games above the .500 mark (69-44). They regained first place on August 12 with an 8–5 win before 23,720 at League Park as Feller won his twentieth game against just six defeats. The rest of the 1940 pennant race in Cleveland would play out at the Stadium.

League Park is considered the birthplace of professional football in Cleveland as the site where the Cleveland Indians defeated the Carlisle Indians on October 8, 1916. Pro football was far from its prominent position in the sports world when played at League Park by the Cleveland Tigers/Indians (1920–21), Indians/Bulldogs (1923–25, 1927), Panthers (1926), Indians (1931) and the Cleveland Rams. The Rams joined the National Football League (NFL) in 1937 and played at League Park in 1937 and some of 1938, 1942, 1944 and 1945 (the team disbanded for a year in 1943 due to manpower shortages caused by World War II). The Bulldogs won a championship in 1924. The 1945 Rams, led by rookie quarterback Bob Waterfield, won the NFL Championship game (played at the Stadium).

During the war years (1941–1945), baseball excitement in League Park was at a minimum. An exception came in July 1941 when the Yankees came

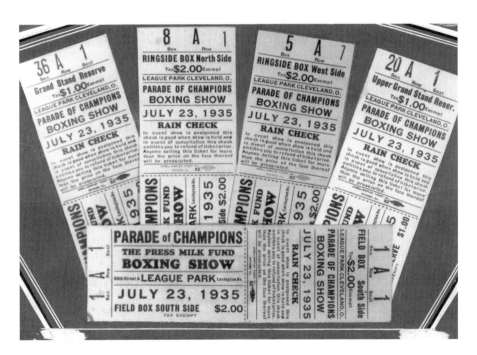

League Park was used for more than professional baseball and football. The Press Milk Fund Boxing Show was staged on July 23, 1935. *Courtesy the Cleveland Press Collection, Cleveland State University Special Collections.*

to town. New York arrived with Joe DiMaggio, the hottest hitter in baseball, on a record-setting hitting streak. On July 16, the great DiMaggio extended the streak to fifty-six games. It ended the following night at the Stadium.

The World War II years were a last hurrah for the Negro Leagues before the Major League Baseball color line was broken and "black baseball" became destined for extinction. Cleveland teams came and went from the Negro Leagues until the Cleveland Buckeyes took hold in 1942 in the Negro American League (NAL).

League Park was ideally positioned for Negro League activity. It was located within walking distance of East 55th Street and the Majestic Hotel. The Majestic, at the corner of East 55th Street and Central Avenue, was called "America's finest colored hostelry."

Led by catcher and manager Quincy Trouppe and outfielder Sam Jethroe, the Buckeyes won the NAL pennant in 1945 and a berth in the Negro League World Series against the legendary Homestead Grays. The first two games were played in Cleveland. The Buckeyes won the first at Cleveland Municipal Stadium and the second at League Park. Game three, at Griffith Stadium in Washington, was another win for the Buckeyes. Finally, at Shibe Park in Philadelphia, Frank Carswell pitched Cleveland to another win, an improbable four-game sweep of the Grays, and the championship of the Negro Leagues.

The Buckeyes won another Negro American League pennant in 1947 but lost the World Series. None of the World Series games was played in Cleveland. The brief, brilliant run of the Cleveland Buckeyes ended in 1950.

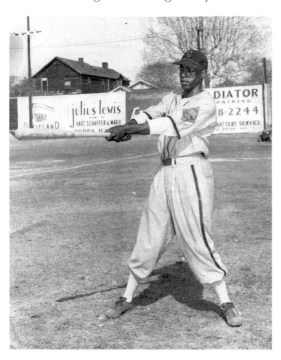

Sam Jethroe was a star outfielder for the 1945 Negro League World Champion Cleveland Buckeyes and later the National League Rookie of the Year with the Boston Braves in 1950. *Courtesy the Cleveland Press Collection, Cleveland State University Special Collections.*

Sports Shrines from League Park to the Coliseum

The last "beginning of the end" of League Park as home of the Indians came on June 22, 1946, when Bill Veeck became principal owner of the team. Veeck negotiated a new lease with the city that would make the Stadium his full-time ballpark.

By then, the League Park neighborhood was decidedly less residential than when the modernized facility opened in 1910. The seating capacity had not been increased, and by 1946 its capacity was the smallest in Major League Baseball. Of all the big-league homes, only League Park, Fenway Park, Tiger Stadium and Wrigley Field remained without lights for night games.

On Saturday, September 21, 1946, the Indians played their final game at League Park. The Tigers beat the Tribe, 5–3, before just 2,772 fans. The Buckeyes continued playing at the site, and in 1949, scenes for the film *The Kid from Cleveland* were filmed there.

The Indians' departure from League Park coincided with larger changes in the Hough neighborhood. From 1950 to 1960, the neighborhood

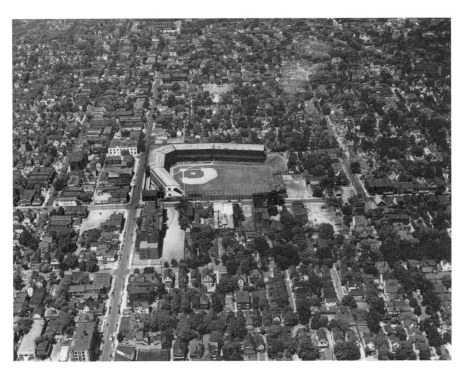

League Park was nestled into a residential neighborhood. Once ideally accessed by trolley, the location was ill-suited for the emerging car culture. *Authors' collection.*

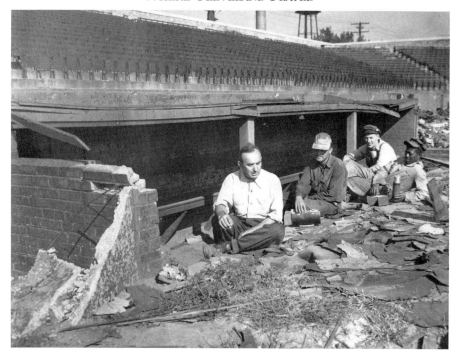

Newman Company employees turned the former Indians dugout into a lunch room as demolition of League Park continued in September 1951. *Courtesy the Cleveland Press Collection, Cleveland State University Special Collections.*

population went from 5 percent nonwhite to 74 percent nonwhite. Overall population of Hough declined from 65,694 to 25,330 from 1950 to 1980.

In 1951, the upper deck was demolished, but the lower deck was left intact and the field was used for practice by the Cleveland Browns. Football legends from Otto Graham and Lou Groza to Bobby Mitchell and Jim Brown left their marks on League Park. Cleveland's last big-time professional world championship team, the 1964 Browns, still practiced at League Park.

Over time, a swimming pool was built where the third-base grandstand had been, and basketball courts were placed behind the office building that served as the entrance at the corner of 66th and Lexington. That building became League Park Center.

For all the modifications, after the Indians, Buckeyes and Browns left, the playing surface was, and still is, there. Kids can still play on the field today in the footsteps of Speaker, Feller, Wambsganss, Jethroe, Jim Brown and other legends.

Sports Shrines from League Park to the Coliseum

Walls at League Park were torn down in 1951, and the area was ultimately turned into a large playground for Hough neighborhood children. *Courtesy the Cleveland Press Collection, Cleveland State University Special Collections.*

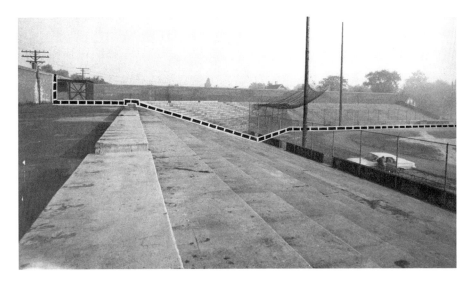

The piecemeal destruction of League Park continued in 1961. What had been the seats behind home plate (above the dotted line) were demolished in the fall. *Courtesy the Cleveland Press Collection, Cleveland State University Special Collections.*

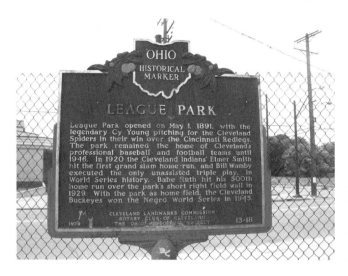

An Ohio Historical Marker was placed near the corner of East 66th and Lexington on League Park Day in 1979. *Authors' collection.*

On August 25, 1979, thirty-three years after the last Indians game there and thirteen years after the Hough riots, League Park Day took place, complete with a souvenir program listing the League Park Committee, and a historical marker was placed at the site. On the 100th anniversary of the 1891 opening day, local members of the Jack Graney Chapter of the Society for American Baseball Research held an impromptu celebration at the site.

When Jane Campbell was elected mayor of Cleveland in 2001, hopes were renewed that League Park would be redeveloped as part of a continuing renaissance of the Hough neighborhood. The following year, the city committed $1.7 million toward a proposed $18 million economic development initiative with restoration of League Park as the centerpiece. Architectural plans were drawn, a promotional video was produced, the wall along East 66th Street was reinforced and the last remaining portion of the grandstand was

The remaining exterior wall of League Park on East 66th Street was reinforced during Mayor Jane Campbell's administration as part of another effort to redevelop the park as a shrine and active sports facility. *Authors' collection.*

Sports Shrines from League Park to the Coliseum

The house that served as administrative offices and ticket windows remains at the corner of East 66th Street and Lexington Avenue. *Authors' collection.*

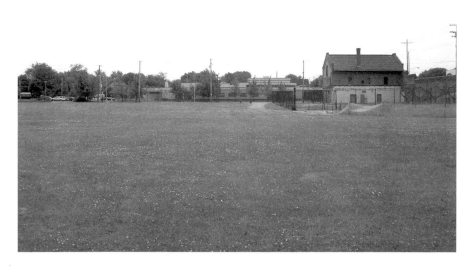

The view from home plate to right field today at League Park still shows how the park favored left-handed batters since the right-field wall was just 290 feet from home plate. *Authors' collection.*

demolished. The demolition revealed, intact, the tunnel leading from the first-base (home) dugout back to both locker rooms (home and visitor).

Following more years of inaction, the League Park Society formed in May 2008 and presented an entirely new plan to restore the historic ballpark. That story is still incomplete.

Cleveland Arena

Before the Cleveland Arena, there was the Elysium—a majestic name for what was the largest ice rink in the country when it opened on November 23, 1907. In just four and a half months and at a cost of about $150,000, the Elysium was constructed on land that was leased from the Case Institute of Technology (now Case Western Reserve University) on the northeast corner of Euclid Avenue and East 107th Street. There were more than twelve miles of pipe needed just to freeze the ice surface. The building originally seated about 1,900, but at times as many as 4,000 were present.

The Humphrey family, owners of Euclid Beach Park, wanted a winter entertainment venue. To that end, they built the curved building that was named the Elysium as a result of a contest. The Elysium offered skating classes and family skating, as well as ice shows, international skating competitions and even band concerts.

During World War I, the Elysium was taken over by Case Institute as a barracks for the Students Army Training Corps. When the war ended, it was reopened as a skating parlor.

The Cleveland Blues were formed in 1920 and played home games in the Elysium as members of the United States Amateur Hockey League until 1925. In 1929, hockey returned in the form of the Cleveland Indians (named after the baseball team), who played the first professional hockey game in Cleveland on November 16. As the depression intensified, attendance dwindled.

The Cleveland Falcons and Cleveland Barons called the Elysium home in the 1930s, but when Al Sutphin opened his much larger Cleveland Arena in

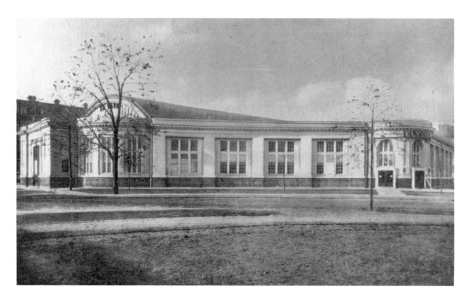

Cleveland's first indoor ice arena, the Elysium, preceded the Arena as home to professional hockey in Cleveland. *Courtesy the Cleveland Press Collection, Cleveland State University Special Collections.*

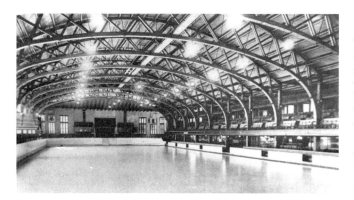

The Elysium was the largest ice rink in the country when it was built by the Humphrey Company and opened in 1907. *Courtesy the Cleveland Press Collection, Cleveland State University Special Collections.*

1937, the demise of the Elysium was in sight. The seating capacity was just not large enough to compete with the larger and more modern Arena. Even the Cleveland Skating Club, which started at the Elysium in 1936, moved to its own private indoor rink.

After the Second World War, the Elysium was called "one of Cleveland's worst eyesores." It was used through the 1940s as a bowling alley and a used car showroom. It was acquired by the city in 1952, and the next January, the Elysium was razed for about $100,000 to widen Chester Avenue.

Sports Shrines from League Park to the Coliseum

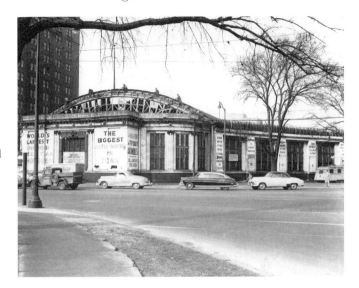

After World War II, auto shows replaced sporting events at the Elysium. The building was torn down in 1953. *Courtesy the Bruce Young Collection, Cleveland State University Special Collections.*

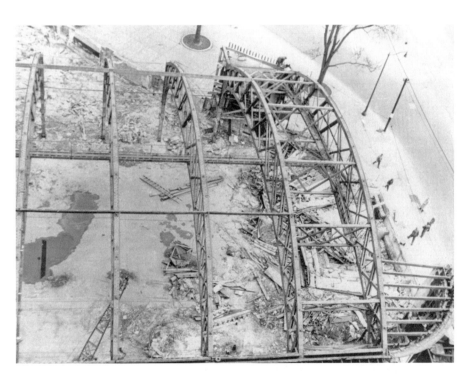

A bird's-eye view of the Elysium as it is razed in 1953 to widen Chester Avenue. *Courtesy the Cleveland Press Collection, Cleveland State University Special Collections.*

Where Cleveland Played

West of League Park and east of Public Square, the Cleveland Arena was Cleveland's indoor mecca for professional sports for more than forty years. It was home to the seventh-best professional hockey team in North America, the American Hockey League (AHL) Cleveland Barons, and was the birthplace of the National Basketball Association (NBA) Cleveland Cavaliers. Hockey and basketball were the dominant attractions at the Arena, but boxing and other entertainment were essential to the overall schedule in the building. One of the historic rock-and-roll events, Alan Freed's Moondog Coronation Ball on March 21, 1952, was another landmark moment in Arena history. Elvis Presley performed at the Arena in 1956.

Al Sutphin is the name most associated with the Cleveland Arena. Sutphin was president of the Braden-Sutphin Ink Company, operating on East 22nd Street, in 1929. By 1937, the company moved east to Chester Avenue. To the south, Sutphin built the Cleveland Arena, with its front door on Euclid Avenue and bordered by Chester to the north, between East 36th Street and East 40th Street. The site had been home to the Brush estate, one of the mansions of Euclid Avenue's famous "Millionaire's Row."

Al Sutphin was the man primarily responsible for the building of the Cleveland Arena and the development of the Cleveland Barons into a hockey powerhouse. *Courtesy the Cleveland Press Collection, Cleveland State University Special Collections.*

Sports Shrines from League Park to the Coliseum

A sports enthusiast, Sutphin became known on the local sports scene as Cleveland's boxing and wrestling commissioner in 1932. At the urging of Cleveland sportswriter Franklin "Whitey" Lewis, Sutphin also turned his attention to hockey.

Pro hockey was relatively new on the scene. Harry "Hap" Holmes conceived the hockey version of the Cleveland Indians in 1929. Sutphin bought the team in 1934 and renamed it the Falcons. In 1936, the team became a charter member of the American Hockey League and played at the Elysium.

Sutphin envisioned more than a hockey rink on Euclid Avenue; he saw a center for many types of entertainment and functions. His proposed arena promised Cleveland the best building of its kind west of New York's Madison Square Garden. Groundbreaking took place on May 8, 1937. Construction was completed on November 10, 1937. The Arena was Cleveland's equivalent of Madison Square Garden, the Montreal Forum and Toronto's Maple Leaf Gardens.

A shrewd businessman, Sutphin also planned to derive additional revenue beyond the Arena itself. Adjacent to the Arena was office and retail space

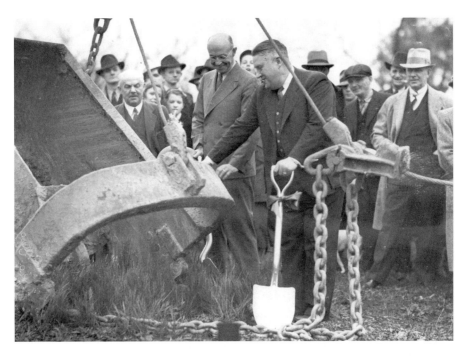

Al Sutphin, shovel in hand, breaks ground for the new Cleveland Arena in May 1937.
Courtesy the Cleveland Press Collection, Cleveland State University Special Collections.

rented by recognizable Cleveland entities like Cleveland Sports Goods and W.F. Ryan Insurance Company.

The building opened on November 17 with an exhibition game between the newly named Cleveland Barons of the AHL and the New York Rangers of the National Hockey League (NHL). More than 6,000 fans saw the Barons lose, 4–3. Weeks later, on December 12, the Arena was packed by 10,003 fans. They saw the Barons defeat Philadelphia, 2–1. Hockey in Cleveland had risen to the popularity of the best NHL teams.

"The Arena is regarded by many competent observers as one of the finest buildings of its type on the continent," noted the 1941–42 hockey program for the Barons. The north lobby, facing Chester Avenue, measured 128 feet by 46 feet and included the Pilsener Bavarian Village, where you could get a locally brewed POC or a Toby Ale. For good measure, you could get a Student Prince cigar for a nickel. The south lobby, facing Euclid, was just half as long but a little wider at 56 feet by 54 feet. The seating capacity was listed at 9,777 for hockey (1,994 red or box seats; 1,532 white seats; 4,657 blue seats; and 1,594 bleacher seats). For boxing matches, the capacity rose to 12,589 with an additional 2,812 seats on the floor. The Brush mansion real estate measured 265 feet from east to west and 572 feet from Euclid to Chester. The Arena itself was 265 feet by 329 feet. Sections were even-numbered from 2 to 42 on the north side and odd-numbered from 1 to 41 on the south. The east-end zone sections were odd-numbered 121 to 129 and the west end zone even-numbered from 122 to 130. Franz Warner of the architectural firm of Warner & Mitchell designed the building. The

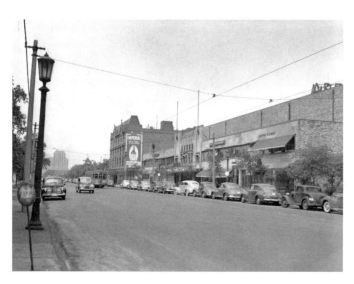

The south and east Arena entrances and W.F. Ryan Insurance Company are all visible along the Euclid Avenue side of the building. *Courtesy the Cleveland Press Collection, Cleveland State University Special Collections.*

construction firm was Gillmore, Carmichael and Olson. The cost was more than $1.3 million.

From the 1937–38 through 1948–49 seasons at the Arena, the Barons finished first in the AHL West Division six times and won the Calder Cup league championship trophy four times. By the early 1940s, the AHL was a distinct competitor to the NHL, and the Barons were considered the seventh-best team in hockey. After increasing to ten teams for the 1941–42 season, the American League contracted to eight in 1942–43 and New Haven folded before season's end. Washington dropped out after the season. The AHL was left with its big six of Cleveland, Pittsburgh, Indianapolis, Buffalo, Hershey and Providence. The NHL was having its own financial troubles. The Barons and Buffalo Bisons were invited to join the National League. Adding Cleveland would have been a boon to the NHL and may have destroyed the AHL. Sutphin chose to keep his Cleveland Barons in the American League.

From 1940–41 to 1949–50, the Barons had the most wins in the AHL with 342 regular-season victories. They brought the Calder Cup back to the Arena in 1941, 1945 and 1948. They lost the cup finals in 1944, 1946 and 1950. By then, the Barons and the Arena had new ownership.

While the Barons chased the 1941 championship, another landmark event took place on March 16 of that year. The first Knights of Columbus track meet in Cleveland featured fifteen events before 6,425 spectators at the Arena. Among the record setters that day was local legend Stella Walsh. The K of C meet was a fixture at the Arena until 1971.

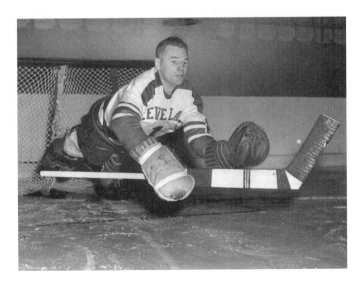

Goaltender Johnny Bower was a star for the Barons and played more than four hundred games for Cleveland before becoming an NHL legend with the Toronto Maple Leafs. *Courtesy the Cleveland Press Collection, Cleveland State University Special Collections.*

Where Cleveland Played

Starting in goal for the Barons on opening night in 1945 was twenty-one-year-old Johnny Kiszkan. Kiszkan changed his name to Johnny Bower and spent thirteen years in the American Hockey League. After eight seasons with the Barons, Bower advanced to the NHL. He returned to Cleveland for the 1957–58 season and left for good after that to tend goal for the Toronto Maple Leafs. He won three Les Cunningham trophies (most valuable player) and three Harry Holmes trophies (top goaltender) in the AHL. In Toronto, Bower was just as good. In eleven seasons with the Maple Leafs, he was net minder for four Stanley Cup champions and played in five NHL All-Star games. He was elected to the Hockey Hall of Fame in 1976.

Bill Cook coached the first two champions, and Bun Cook coached the next five. Jack Gordon succeeded Bun Cook and won the cup his first time out (1956–57). Fred Glover guided Cleveland's final cup winner (1963–64), but the club never had a forty-win season or finished first in the regular season after 1952–53.

The 1948 Calder Cup trophy victory was the pinnacle, the first of three Cleveland championships that year. Sutphin decided to go out on top. A

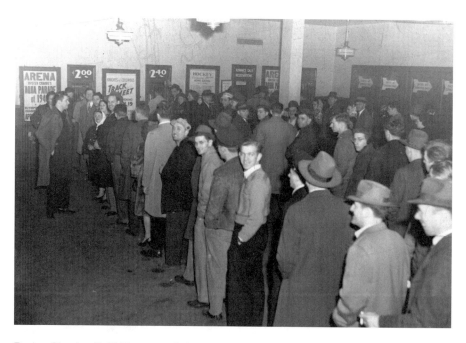

During Cleveland's 1948 season of champions, hockey fans crowded the Arena lobby and endured a two-hour wait to purchase playoff tickets. *Courtesy the Cleveland Press Collection, Cleveland State University Special Collections.*

year after the Barons' third Calder Cup win of the decade, he sold the team and the Arena on April 25, 1949. Sutphin had spent much time building a sports/entertainment empire and, at fifty-five years old, decided that he wanted to spend more time with his family.

Purchasing the stock of Sutphin and his principal associate, Carl Lezius, were Minneapolis construction contractor George Drake, his partner George Heller and Lyle Z. Wright, principal owner of the Minneapolis hockey club of the United States League. Drake and Heller had been in the hockey and winter sports business since 1923.

Surprisingly, the 1952 Moondog Coronation Ball at the Arena was not a big newspaper story. Reports varied on the size of the crowd, but it was clearly more than the Arena could handle. The end result was hardly a success, if not a full-fledged debacle, but the Moondog Coronation Ball lives in history as the original rock concert and a touchstone in Cleveland's claim to being the birthplace of rock and roll.

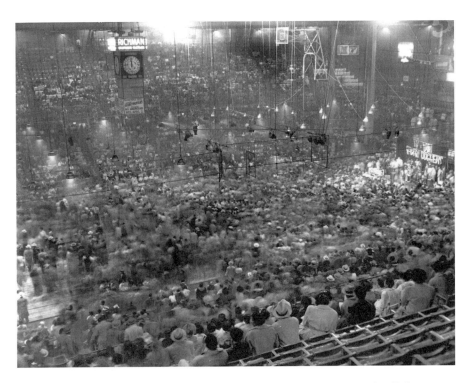

Early rock-and-roll fans clog the Arena for Alan Freed's Moondog Coronation Ball on March 21, 1952. Photo by Hastings and Willinger. *Courtesy the Cleveland Press Collection, Cleveland State University, Special Collections.*

Where Cleveland Played

Two months after Alan Freed's show, the new owners of the Barons set the team toward the highest level of professional hockey. By July 2, 1952, they were poised to bring the NHL and its "Big Six" to the Arena as the seventh franchise at the pinnacle of the hockey world. Instead, on July 2, Cleveland's application to join the NHL was surprisingly denied. Decades later, Cleveland would have a NHL team, but under decidedly inferior circumstances.

Even with the change to out-of-town ownership, the Barons remained an AHL powerhouse in the 1950s, with four more Calder Cup–winning seasons. Leading the way was new general manager James C. Hendy, who emerged to establish his own legend as a hockey executive. Hendy would ultimately be elected to the Hockey Hall of Fame in 1968.

Constants for the Barons from 1952–53 through 1959–60 were Hendy, Jack Gordon and Fred Glover. When Hendy died suddenly on January 14, 1961, Gordon added general manager to his coaching duties. Glover powered the Cleveland offense and set the standard for scoring in the AHL. When Gordon left for the New York Rangers after the 1964–65 season, Glover became player-coach and club president Paul Bright took on the general manager duties.

Boxing was an important Arena activity. Boxing legends who appeared at the Arena included Jake LaMotta, Sugar Ray Robinson, Sonny Liston,

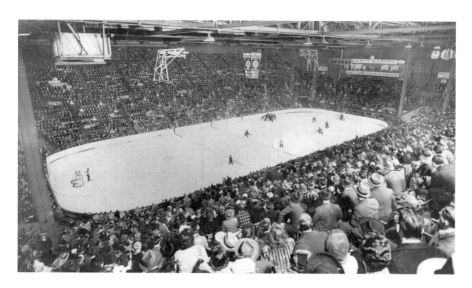

The Barons could still draw big crowds in 1967, but the days were numbered for the team and the Cleveland Arena. *Courtesy the Cleveland Press Collection, Cleveland State University Special Collections.*

Sports Shrines from League Park to the Coliseum

Floyd Patterson and Muhammad Ali. Boxing fans much anticipated a world championship fight at the Arena on June 24, 1947, between welterweights Robinson and Jimmy Doyle. It was the first championship fight in Cleveland since Max Schmeling beat Young Stribling in 1931 at the Stadium. Some questioned if Doyle was worthy of a match with Robinson, but his record was a solid one.

Robinson dominated the fight and finally, in the eighth round, dropped Doyle to the canvas with a left hook. Doyle was counted out and remained unconscious for minutes before he was taken on a stretcher out of the ring to an ambulance and off to St. Vincent Charity Hospital. Seventeen hours after the fight, Doyle was pronounced dead. He was reportedly the first fighter in modern boxing history to die from injuries suffered in a world championship bout.

The forerunner of the NBA, the Basketball Association of America, placed a team in Cleveland for its initial 1946–47 season. On opening night, November 3, 1946, the Rebels drew 7,594 to the Arena and defeated Toronto, 71–60, as Ohio University legend Frankie Baumholtz scored twenty-five points for Cleveland. The Rebels won thirty of sixty games in 1946–47, but the team disbanded after that one season.

The Cleveland Pipers of the American Basketball League played at the Arena, Public Hall and Baldwin-Wallace Gymnasium in 1961 and 1962. George Steinbrenner cut his professional sports ownership teeth on the Pipers. Two Hall of Famers, John McLendon and Bill Sharman, served as head coaches of the club. McLendon is recognized as the first black head coach in professional sports for his stint with the Pipers.

Cleveland won the league championship on April 9, 1962, in Kansas City with Sharman at the helm. The Pipers might have brought NBA basketball to Cleveland in the early 1960s, but legal maneuvering got in the way and the charter franchise disbanded instead. It would be for another maverick entrepreneur to bring the NBA to Cleveland.

Starting in the fall of 1966, Ohio's only NBA team, the Cincinnati Royals, began playing some of its regular-season games at the Arena. From November 25, 1966, to February 3, 1970, the Royals played thirty-five games in Cleveland. The February 17, 1967 game between the Royals and eventual NBA champion Philadelphia 76ers attracted 11,036 fans. In the January 26, 1969 Royals-Lakers game, Wilt Chamberlain scored sixty points. These games helped pave the way for Cleveland to obtain an NBA team of its own.

The most memorable of the Cincinnati games was on November 28, 1969, when the New York Knicks came to town riding a seventeen-game

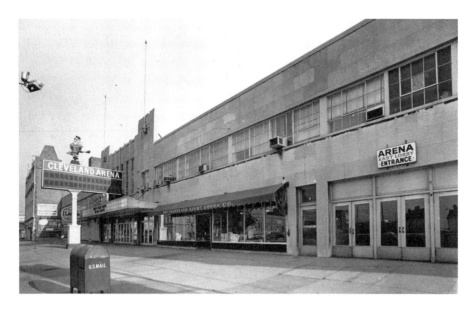

The Cleveland Sport Goods Company and a new sign featuring the "Baron" appear between the south and east entrances to the Arena on Euclid Avenue. *Courtesy the Cleveland Press Collection, Cleveland State University Special Collections.*

winning streak. The Knicks beat the Royals, 106–105, and set a league record with eighteen straight wins. They went on to win the 1969–70 NBA title.

As the building passed thirty-five years old and showed its age, a daring entrepreneur swept in to buy the Arena and the Barons. Like Bill Veeck in the 1940s, Nick Mileti took Cleveland by storm and, for a brief time, nearly monopolized pro sports on the north coast. When Mileti, backed by the financial muscle of C.F. Kettering, completed purchase of the Barons and the Arena on September 27, 1968, from Paul Bright and groups of Cleveland, Detroit and California investors (including the Shipstead Johnson family, former owners of the Ice Follies), the hockey team and its home building were back under the same ownership for the first time since the days of Al Sutphin.

Mileti established a Cleveland Barons Hockey Hall of Fame. Fred Glover was the first inductee. "Builders" Sutphin and Fred "Bun" Cook were honored, as were pre-1950s players Danny Sprout, Les Cunningham, Bobby Carse and Morris "Moe" Roberts. Jack Gordon, Fred Thurier and Eddie Olson joined Glover as post-1950s honorees. Plaques honoring the Hall of Famers were displayed in the Euclid Avenue lobby.

Sports Shrines from League Park to the Coliseum

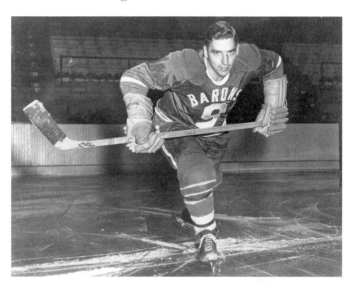

Fred Glover was arguably the greatest player in Cleveland Barons history and also guided the team to its final Calder Cup Championship as player-coach in 1963–64. *Courtesy the Cleveland Press Collection, Cleveland State University Special Collections.*

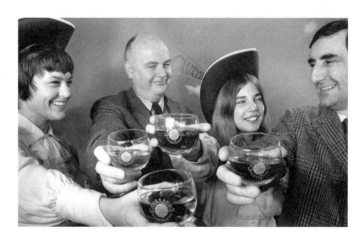

Because of local liquor laws, Nick Mileti (right) leads a dry toast with souvenir glasses, marking the first home game of the Cavaliers on October 28, 1970. *Courtesy the Cleveland Press Collection, Cleveland State University Special Collections.*

Next, Mileti pursued a team in the National Basketball Association. In February 1970, Cleveland was granted one of three NBA expansion franchises to begin play in the fall.

On opening night, October 28, 1970, the Cavaliers, in their wine and gold uniforms, took the court against the San Diego Rockets. The top ticket price was $6.00 for a front-row seat. An upper-level end zone seat was $2.50. The Rockets beat Cleveland, 110–99, before 6,144 fans at the Arena. The new Cavaliers went on to lose the first fifteen games they played before finally winning at Portland. The Cavs were just 1-27 when they won at the Arena

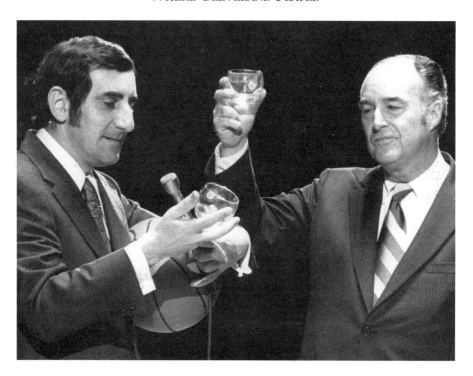

NBA commissioner Walter Kennedy (right) and Nick Mileti salute the Cavaliers' first home game on October 28, 1970, at the Cleveland Arena. *Courtesy the Cleveland Press Collection, Cleveland State University Special Collections.*

for the first time on December 6, 1970. They nipped Buffalo, 108–106, before just 2,002 fans.

The Cavaliers won just fifteen games in 1970–71 against sixty-seven losses, by far the worst record in the NBA. One of the most memorable games at the Arena that season took place on February 15, 1971, when center Walt Wesley of the Cavaliers had his greatest game against his former club, the Royals. The six-foot-eleven center scored fifty points, a team record that stood until broken by LeBron James on March 20, 2005, at Toronto. Lew Alcindor did better with fifty-three points on November 4, 1970, and again, as Kareem Abdul Jabbar, on February 9, 1972, for the Milwaukee Bucks.

Cleveland had a new team and the smallest seating capacity in the NBA. Access to the Arena was a problem due to limited parking spaces and limited public transit options.

The best thing about losing sixty-seven games was earning the right to pick first in the 1971 college draft. With that pick, the Cavaliers chose Austin

Sports Shrines from League Park to the Coliseum

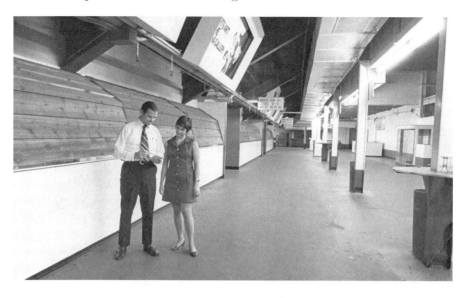

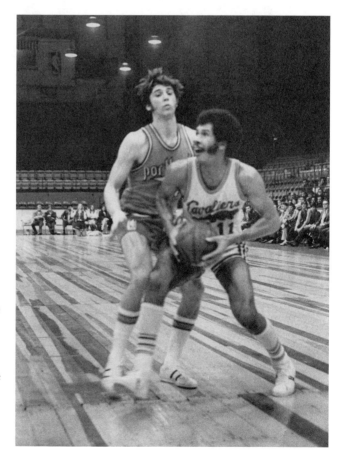

Above: Cavaliers PR chief Bob Brown and his assistant Kathy Haley in the south lobby at the Arena. *Courtesy the Cleveland Press Collection, Cleveland State University Special Collections.*

Right: John Warren (11) and the 1970–71 Cavaliers played before many empty seats at the Arena. *Courtesy the Cleveland Press Collection, Cleveland State University Special Collections.*

Dave Sorenson (15) puts the finishing touch on Cleveland's first winning streak, a victory over Portland at the Arena, the team's second straight win.
Courtesy the Cleveland Press Collection, Cleveland State University Special Collections.

Carr of Notre Dame. Carr began a fine NBA career with the Cavs at the Arena and remains a popular figure in Cleveland as a color commentator on the team's local television broadcasts.

Cleveland was called "the Best Location in the Nation," but the east side of downtown Cleveland was not the place to be in the early 1970s. Like many other urban areas, downtown Cleveland was in decline. The Hough riots of the 1960s left many people afraid to go downtown, especially at night.

Everything is relative. While some saw the Arena as an aging, outdated facility ("a dump"), others saw it as a place of excitement and color. It was Cleveland's home to pro basketball and pro hockey. Fans went there to see the circus, the Ice Capades, boxing or wrestling.

The neighbors still included the Sheraton at 3614 Euclid Avenue; the Masonic Auditorium on the northeast corner of East 36th Street and Euclid; and the University Club at 3813 Euclid. The auditorium was built by the Masons in 1919 and remains standing today. The University Club, formerly the Beckwith mansion, was part of Millionaire's Row and one of the Row's last remaining mansions. In the 1940s, the Hotel Belmont was located across the street, with Harry Mamolen's restaurant and Mexican cocktail room inside. Also across the street was the 3700 Club at 3738 Euclid ("come early and enjoy our one dollar chicken dinner served from 5:30 till 9:00 pm with complete floor show at 8:00 pm; four shows nightly with no cover and no minimum").

Meanwhile, America's car culture continued to grow. Suburbs to the east of Cleveland were expanding, and the Akron-Canton area, southeast of Cleveland, brought the population of the overall region to about five million. Tapping into that population with a sports palace centrally located between Cleveland, Akron and Canton and stocked with plenty of parking spaces fit a considerable view of the future. Kansas City had its Harry S. Truman Sports Complex, New York had it Meadowlands and many other pro sports communities broke ground on new suburban sports facilities.

Almost from day one, the focus of Mileti and the Cavaliers was a new building along side Interstate 271. The franchise had one eye on becoming competitive in the Arena and the other on a new home. To the former end, Mileti and Head Coach Bill Fitch brought two recognizable basketball stars to Cleveland. First came Austin Carr. Next, they traded for veteran all-star Lenny Wilkens, who had been player-coach of the Seattle Supersonics.

The Cavaliers continued to lose, and attendance was sparse for many games, but the team was building toward a bright future. The Barons were not.

By 1971, the NBA Cavaliers were the dominant attraction at the Arena. Then came the Barons. The Ice Capades came to town in October, followed by the circus, Disney on Parade and the Ice Follies. There was also wrestling, roller games, college hockey and the Harlem Globetrotters.

The arrival of the NBA Cavaliers relegated minor league hockey to fourth place in the Cleveland sports universe. Once the seventh-best team in professional hockey, the Barons were subject to the whims of their NHL affiliates and decidedly inferior to the expanded National League. When Mileti could not land a team in the established NHL, he turned to the upstart World Hockey Association (WHA).

The WHA, like the American Football League and the American Basketball Association of the 1960s, came on the scene before major league sports had reached a saturation point in America. Big cities (traditional and emerging) like Cleveland, Buffalo, Anaheim, Oakland, Dallas and others

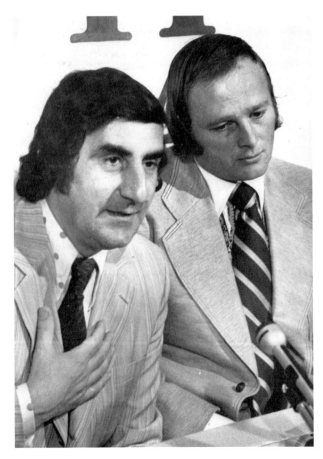

Nick Mileti (left) lured star goalie Gerry Cheevers from the NHL Boston Bruins to anchor the new Cleveland Crusaders of the WHA. *Courtesy the Cleveland Press Collection, Cleveland State University Special Collections.*

strove to attract initial or additional major league teams and enhance their positions as major league cities.

On June 21, 1972, Nick Mileti acquired the WHA franchise originally slated to play in Calgary. Hardly a month later, he gave the new Cleveland Crusaders instant credibility by signing superstar goaltender Gerry Cheevers of the Boston Bruins.

The WHA Crusaders debuted on October 11, 1972, against the Quebec Nordiques. The Arena, with its chicken wire, packed with 9,681 fans, finally had its own major league hockey team. Bob Dillabough scored the first Cleveland goal, and Gerry Cheevers shut out Quebec, 2–0.

The Crusaders were 53-19-6 at the Arena in two seasons and advanced to the playoffs in both. The fourth game of the first round of the 1973–74 playoffs was a must-win for the Crusaders, and 8,812 saw a thrilling, 3–2 overtime victory for the "purple gang," over the Toronto Toros. Wayne Muloin scored the winning goal in the last professional hockey game at the Arena. Toronto won the series in five games.

The arrival of the Crusaders meant the end of the Barons. Only 412 fans turned out on January 8, 1973, for the Barons' final game at the Arena.

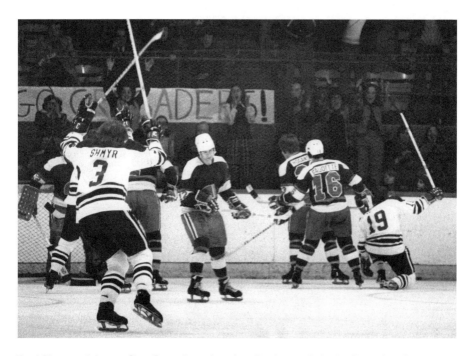

Paul Shmyr celebrates Gary Jarrett's goal against Quebec early in the Crusaders final season at the Arena. *Courtesy the Cleveland Press Collection, Cleveland State University Special Collections.*

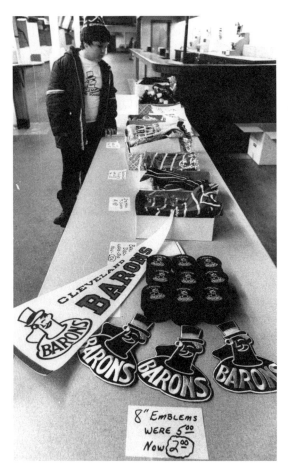

The once busy south lobby of the Cleveland Arena became the site of a garage sale of old Barons souvenirs. The Barons had moved to Jacksonville.
Courtesy the Cleveland Press Collection, Cleveland State University Special Collections.

Mileti moved the team to Jacksonville, Florida. The team lasted just one full season (1973–74) in Jacksonville and folded.

On December 1, 1972, Lenny Wilkens surpassed the fifteen-thousand-point plateau, only the sixteenth player in NBA history to do so, when the Cavs played the Detroit Pistons at the Arena. Bobby "Bingo" Smith and John Warren deserve special recognition among the early Cavaliers as the only two players on hand for each of the four openers at the Arena.

Of Cleveland's thirteen wins at the Arena in 1971–72, the last was a memorable upset of the record-setting Los Angeles Lakers. The Lakers, winners of thirty-three straight games earlier that season, were on track to win an unprecedented seventy games when they invaded the Arena on March 22, 1972. The Cavs handed the Lakers a 124–120 loss before 10,819 fans. The Lakers finished the season with a league record sixty-nine wins.

The Cavs were 62-102 in home games during their four seasons (1970–71 through 1973–74) at the Arena. The sixty-second win came against the world champion New York Knicks, 114–92, on March 24, 1974, before 8,829 at the Arena. The win was Cleveland's eighth in thirteen games. A bright future at the Coliseum appeared to be in sight, but there was little future left for the Arena.

Sports Shrines from League Park to the Coliseum

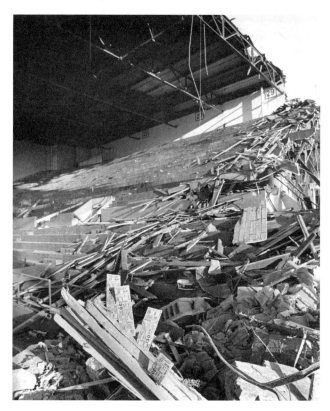

Right: Demolition of the Arena continues near Section 29. Notice the unused tickets from the March 30, 1973 Crusaders game against Winnipeg. *Courtesy the Cleveland Press Collection, Cleveland State University Special Collections.*

Below: After all negotiations to save the Arena failed, demolition of the building took place in 1977. *Courtesy the Cleveland Press Collection, Cleveland State University Special Collections.*

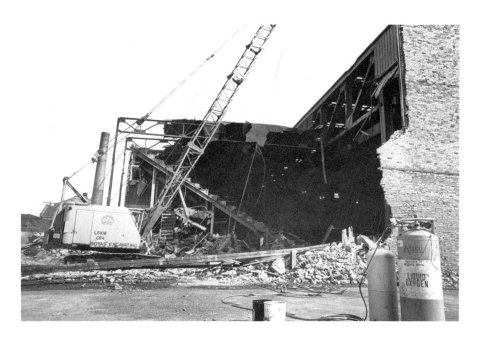

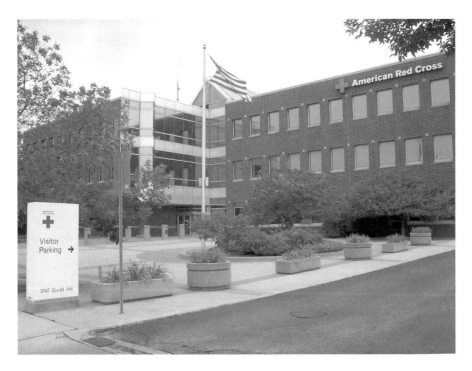

This page: Cleveland's American Red Cross headquarters replaced the Arena at 3747 Euclid Avenue some thirty-seven blocks to the east of downtown. *Authors' collection.*

Efforts by Mileti to sell the building to the City of Cleveland or other entities came to no avail. In the end, like the Boston Garden, Montreal Forum, the original Madison Square Garden and other, similar buildings, the Arena was demolished.

Mileti donated the land to his alma mater, Bowling Green State University. BG sold it to the Red Cross. Cleveland's branch of the Red Cross remains at the site today. Not a plaque, photo or any commemoration of the Cleveland Arena and all it meant to so many can be found there. There is no mention that Elvis was there, or Alan Freed, or nine Calder Cup Championship Barons teams. There is no mention that thousands of fans found excitement and enjoyment at that spot for nearly four decades.

The Coliseum

Nick Mileti was born in 1931 to immigrant parents. He learned the importance of hard work as a youngster, holding three jobs at a time to earn money and survive a rough environment. After graduating from Cleveland's John Adams High School, he went on to Bowling Green State University and followed that by earning a law degree from The Ohio State University.

Mileti became a prosecuting attorney in Lakewood, Ohio, and founded Senior Consultants, Inc., a senior housing consulting business. He became a nationally recognized expert in the field of nonprofit housing for the elderly.

In 1968, he burst into Cleveland's sports scene. At the time, the NFL Browns and MLB Indians were Cleveland's major league teams, and the AHL Barons played minor league hockey at the Arena. Mileti bought the Arena and Barons that year for about $1.5 million and went to work to bring the NBA to Cleveland.

The Cavaliers joined the Buffalo Braves and Portland Trailblazers as NBA expansion teams for the 1970–71 season. It was clear that the Cavaliers needed a better home than the deteriorating Arena, and in June 1971 Mileti announced plans for a new sports and entertainment venue.

In 1972, he bought the Indians, explaining, "I had no choice but to buy them. They were going to be moved to New Orleans. They're a Cleveland team; they needed to stay in Cleveland."

Mileti wanted to see major league hockey in Cleveland as well. Denied an NHL franchise in 1972, he applied for and was granted one in the upstart World Hockey Association. He took over the defunct Calgary Broncos,

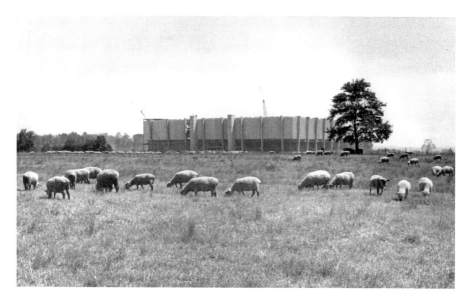

Three months before opening, construction continues and sheep graze in their former home as the Coliseum grows in Richfield, Ohio. *Courtesy the Cleveland Press Collection, Cleveland State University Special Collections.*

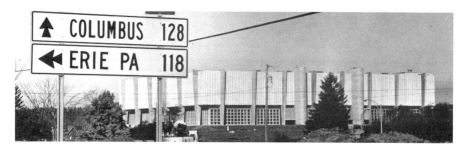

Fans from as far as Columbus, Ohio, and Erie, Pennsylvania, could easily reach the Coliseum within about two hours. *Courtesy the Cleveland Press Collection, Cleveland State University Special Collections.*

and the Crusaders were born. They would play in the Arena until the new entertainment center was ready.

Nick Mileti was a visionary. While the concept of regionalism was in its infancy, Mileti determined that a centrally located new arena would be convenient for the more than five million people in northeast Ohio. He built his modern new arena, called the Coliseum, on a 109-acre parcel at the intersection of State Route 303 and I-271 and just south of the Ohio

Sports Shrines from League Park to the Coliseum

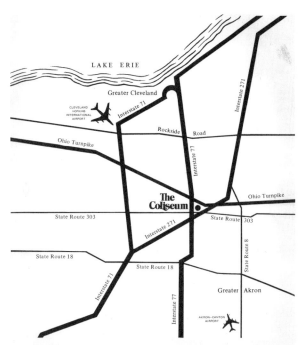

The Coliseum was built at the crossroads of Interstate 271, Ohio State Route 303 and the Ohio Turnpike, an easy drive for five million northeast Ohioans. *Courtesy the Cleveland Press Collection, Cleveland State University Special Collections.*

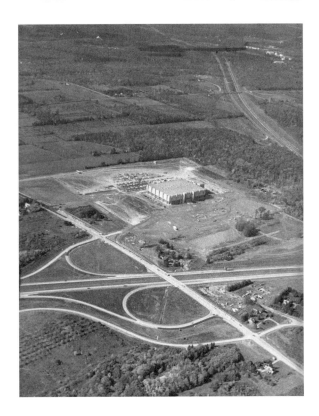

The Coliseum takes shape north of Ohio State Route 303 in Summit County. *Courtesy the Cleveland Press Collection, Cleveland State University Special Collections.*

turnpike in the village of Richfield. He believed that the Coliseum would spark growth in the form of hotels, restaurants and other businesses in the area. Unfortunately, that anticipated growth never followed. The beautiful building sat in the middle of a parking lot for its entire existence. Mileti later said, "I'm surprised it's still such a sleepy spot. It has a lot of potential."

On March 16, 1973, ground was broken for construction of the Coliseum in Richfield. The Coliseum combined the best ideas from other arenas, builders and performers. There were cocktail lounges and theater-type seats, as well as the most advanced video display system available—the Telscreen. The new Conrac computer-controlled Telscreen system was the first used in a midwestern arena and provided color television pictures, close-ups, slow-motion replays, statistics and highlights on two fifteen- by twenty-foot television screens. Images were projected onto screens at the north and south ends of the Coliseum by Eidophor Television Projectors, which were known for their outstanding picture quality and brightness.

The main Telscreens were flanked by two smaller advertising screens that were illuminated by slide projectors. There were also solid-state matrix scoreboards on the east and west sides of the Coliseum so fans could see a scoreboard from any seat.

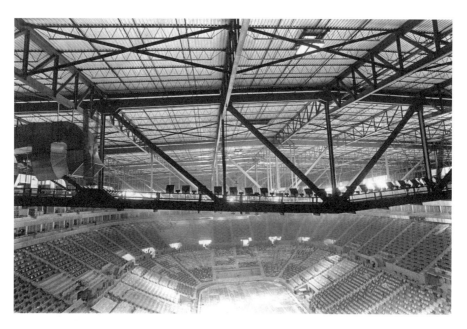

Three 700,000-pound beams across the top of the building supported the roof of the Coliseum. *Courtesy the Cleveland Press Collection, Cleveland State University Special Collections.*

Sports Shrines from League Park to the Coliseum

From the beginning, the biggest problem the Coliseum faced was its location. While it was a half-hour or so drive for millions, it was not really close to anyone. It was fine for people in Akron to drive to the closer Summit County arena, but perception is reality. Cleveland and Cuyahoga County suburbanites felt like they were driving to the wilderness. Even though it didn't take much longer to go to the Coliseum on the highway than it did to get downtown on city streets, Cuyahoga County residents generally didn't like to make the trip. Add the traffic that backed up at times on highway exits and the trouble getting into and out of the parking lots off Route 303, and there was a perception of inconvenience about the location.

There was never any real public transportation to the Coliseum nor alternative parking to the huge lot that surrounded it. Eventually, another entrance to the back of the parking lot was cut through the woods off Black Road, making access a little easier for fans coming from the north.

Once inside the Coliseum, fans entered a wide but somewhat colorless concourse with concession stands, souvenir stands and restrooms. A walk through any of the many portals into the inner concourse made every section easily accessible. All of the sections (both lower and upper) were reached from the inner concourse that circled the arena. Sections were numbered 101 to 144 (lower) and 201 to 244 (upper), starting at the north end zone.

Seats were different shades of tan and brown. Pete Franklin, Cleveland's radio sports-talk pioneer, described the paint on the basketball floor as "azure blue." The Coliseum stood 123 feet high, and the volume was sixteen million cubic feet, big enough to hold thirty-seven million basketballs.

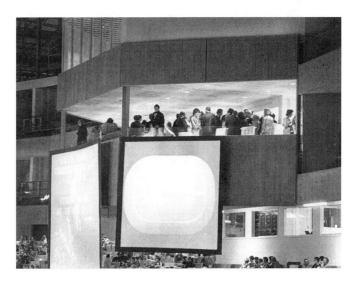

Telscreens at each end of the Coliseum brought video replays to fans attending the game. These are located underneath Nick Mileti's super box. *Courtesy the Cleveland Press Collection, Cleveland State University Special Collections.*

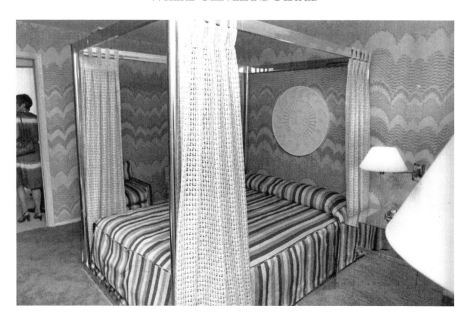

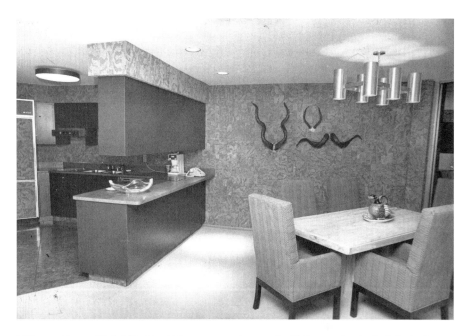

This page: Owner Nick Mileti had his own super loge at the Coliseum that included a bedroom and kitchen. *Courtesy the Cleveland Press Collection, Cleveland State University Special Collections.*

Sports Shrines from League Park to the Coliseum

Legendary entertainer Frank Sinatra was slated to open the Coliseum on October 26, 1974, and it took some Nick Mileti creativity to make that possible since Sinatra was difficult to book. While overseas in Rome, Mileti had a thought. He would make opening night a fundraiser for an educational foundation devoted to Italian-American children and asked Sinatra's manager if Frank would help. After some negotiating, Sinatra's manager explained that if John Volpi, the first American ambassador to Italy, would call him, Sinatra would perform. So, while in Rome, Mileti went to Volpi's home, explained the situation and made arrangements for Sinatra to open the Coliseum. Sinatra made $250,000, and opening night was a success.

After the concert, Mileti threw a party at the Coliseum Club on the loge levels for two thousand guests. It was so crowded that one guest said it took him as long to get a drink as it did to get into the parking lot. Everyone in attendance received a medallion on a gold-plated chain showing the Coliseum on one side and an etching of Sinatra (who did not attend the party) on the other. Mileti borrowed the idea from former Cleveland restaurateur Billy Weinberger, who had used the idea at Caesars Palace in Las Vegas.

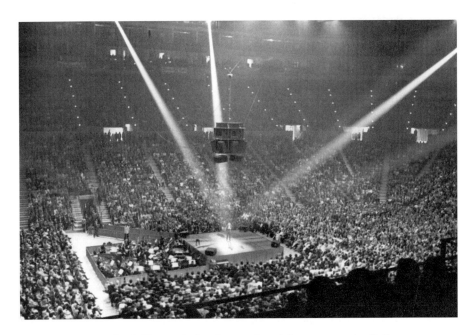

Spotlights focus on Frank Sinatra during the opening-night concert at the Coliseum on October 26, 1974. *Courtesy the Cleveland Press Collection, Cleveland State University Special Collections.*

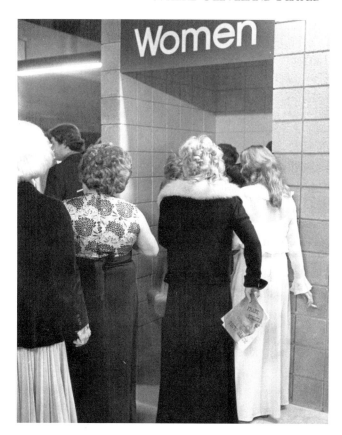

Coliseum amenities included more restrooms, but women were still waiting in line on opening night. *Courtesy the Cleveland Press Collection, Cleveland State University Special Collections.*

The Coliseum, at 2923 Streetsboro Road (Route 303) in Richfield, Ohio, was open and ready for business. The first sporting event in the new building was scheduled for the next night—a World Hockey Association game between the Cleveland Crusaders and the Toronto Toros. Unfortunately, in the rush to complete the Coliseum, there was not enough time to sufficiently test the ice surface, and as workers prepared the rink for the game, they discovered that the ice was not freezing properly. Blocked refrigeration pipes near center ice were the culprits. The game was called off at 3:15 p.m., but thousands of fans didn't get the word and arrived at the Coliseum only to discover there would be no game.

The next home game was scheduled for Wednesday, October 30. Assuming that the ice problems were solved, more than nine thousand fans arrived to see the Crusaders play the Minnesota Fighting Saints. As players began the pregame skate, it was clear that the ice was not playable. The pipes were still not working. About 9:30 p.m., General Manager Jack Vivian

Sports Shrines from League Park to the Coliseum

Symbolic of its time, the Coliseum was surrounded by surface parking. The lot could accommodate more than six thousand cars. Public transit access was minimal. *Courtesy the Cleveland Press Collection, Cleveland State University Special Collections.*

made the embarrassing announcement that the game could not be played. Minnesota coach Harry Neale said that the ice at the north end was so bad that "it would be an unplayable lie if you're a golfer."

After a road game, the Crusaders returned for Opening Night III on Saturday, November 2. They practiced on the ice the day before and reported that it was satisfactorily thick and smooth. Crusaders fan favorite Ron "Bucky" Buchanan, who had been traded to Edmonton a week before, led the visiting Oilers to a 4–2 win in front of 13,263 fans. Buchanan scored the first goal at the Coliseum early in the first period. Less than two minutes later, Ron Ward scored the first Crusaders goal and tied the game, 1–1, but Buchanan's three-point night led the Oilers to the win.

Cleveland finished the season in second place in the Eastern Division with just a 35-40-3 record. They faced the eventual league champion Houston Aeros—led by the Howe family (Hall of Famer Gordie with sons Mark and Marty)—in the playoffs. After two road losses, the Crusaders

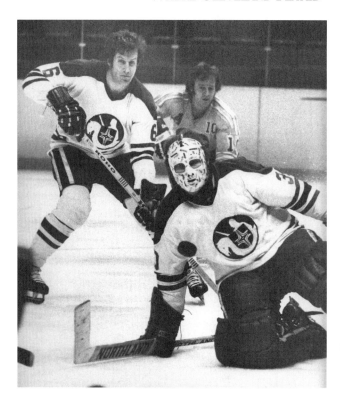

Gerry Cheevers, in his distinctive goalie's mask, and Ray Clearwater of the Crusaders defend the net at the Coliseum in 1975. *Courtesy the Cleveland Press Collection, Cleveland State University Special Collections.*

won the third game at the Coliseum by a score of 3–1 but lost the series in five games.

Two days after the first ice disaster, the Coliseum's primary tenant, the NBA Cavaliers, played their first game in the new building. The Cavs opened the 1974–75 season on a six-game road trip that took them to both coasts, from which they came home 3-3, with a three-game winning streak, to play the reigning champion Boston Celtics. A crowd of 13,184 watched the Celtics rout the Cavs 107–92. "We went right back to that first game we ever played at the Arena," said Coach Bill Fitch. After an off day, the Cavs won their first game at the Coliseum, 118–101, against the Detroit Pistons.

January 1975 saw $30,000 of damage done to the Coliseum as disgruntled Led Zeppelin concertgoers who had arrived without tickets tried to push their way inside. While twenty-one thousand fans enjoyed the two-and-a-half-hour concert, others smashed windows and doors with chunks of concrete. At least nine people were arrested in the incident.

Sports Shrines from League Park to the Coliseum

I was present at the First CAVALIER GAME at the Coliseum October 29, 1974

CAVALIER ROSTER

#	Pos	Player
52	F-C	Jim Brewer
34	G	Austin Carr
22	C	Jim Chones
35	G	Jim Cleamons
42	F	Dwight Davis
24	F	Fred Foster
50	C-F	Steve Patterson
31	G	Mike Robinson
20	F	Michael (Campy) Russell
7	F	Bobby Smith
10	G	Dick Snyder
14	G	Clarence (Foots) Walker
11	G	John Warren
44	C	Luke Witte

General Manager and Coach: Bill Fitch
Assistant Coach: Jim Rodgers
Trainer: Charlie Strasser

This page: For the Cavaliers' opener at the Coliseum, fans were presented with a souvenir card. The opening-night roster included most of the members of the "Miracle of Richfield" team. *Authors' collection.*

World's Greatest Fan Club

Nº 05771

CAVALIERS CLEVELAND

Coliseum

CHARTER MEMBER

GENERAL MANAGER PRESIDENT

WHERE CLEVELAND PLAYED

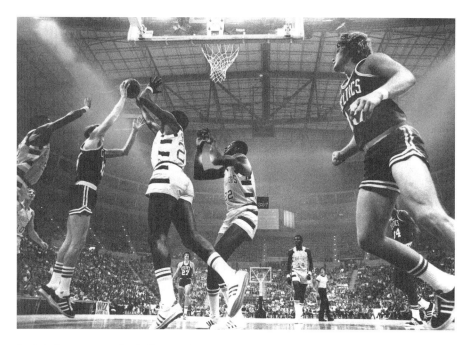

In their first game at the Coliseum, Cavaliers Jim Brewer, Dick Snyder, Fred Foster, Jim Chones and Foots Walker (left to right) watch John Havlicek shoot for the Celtics. *Courtesy the Cleveland Press Collection, Cleveland State University Special Collections.*

The Mileti sports empire had reached its zenith. More interested in building than maintaining, he began pulling back, starting with the sale of controlling interest in the Crusaders. Jay Moore became the new majority owner.

The Cavaliers battled through an injury-plagued season and came into their last home game needing a win to keep hopes for a first playoff berth alive. On April 3, 1975, a single-game NBA record crowd of 20,239 cheered the Cavs to a 100–95 victory against the New York Knicks.

With their first playoff appearance in sight, the Cavs hit the road to finish the season in Kansas City, knowing that they needed to win. Trailing by fourteen points with four minutes to play, a furious rush found them trailing just 95–94 with three seconds left. When Fred Foster's jumper was blocked at the buzzer, the Cavaliers found themselves waiting another year to make the playoffs; however, a 29-12 record the first year at the Coliseum gave them the foundation for what would become the "Miracle of Richfield."

As the first season of hockey and basketball was wrapping up at the Coliseum, the building was being prepared for the first heavyweight title

Sports Shrines from League Park to the Coliseum

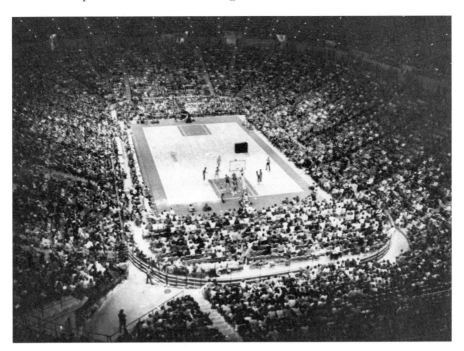

An NBA single-game record crowd of 20,239 attended the April 3, 1975 game between the Cavaliers and the New York Knicks at the Coliseum. *Courtesy the Cleveland Press Collection, Cleveland State University Special Collections.*

fight in Cleveland since the Schmeling-Stribling bout in 1931 opened the Stadium. Unknown Chuck Wepner, a liquor salesman from Bayonne, New Jersey, fought heavyweight champion Muhammad Ali on March 24, 1975. Before the fight, the giant Telscreens beamed a closed-circuit bout between Jerry Quarry and Ken Norton from Madison Square Garden. Norton won by TKO in the fifth round. The Telscreen reception was especially good for the fight. Engineer Jim Snell and his group had worked for weeks to improve the video presentation.

More than fifteen thousand fans paid between $10 and $75 to watch the surprising Wepner battle the champion into the fifteenth round before referee Tony Perez stopped the bloody battle with nineteen seconds left. Ali was "knocked down" by Wepner in the ninth round with a strong right blow to the body (and with Wepner's foot on Ali's), but the victory belonged to Ali. He earned $1.5 million for his effort, while Wepner got $100,000. The fight is considered by many to be the basis for the Academy Award–winning movie *Rocky*.

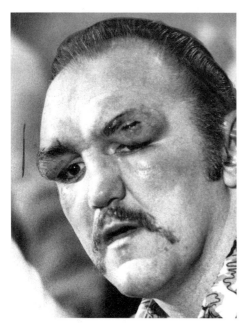

Chuck Wepner after his heavyweight title fight with Muhammad Ali in 1975 at the Coliseum. *Courtesy the Cleveland Press Collection, Cleveland State University Special Collections.*

The Cavaliers opened the 1975–76 season at home losing by six to the NBA champion Golden State Warriors and floundered to a 6-11 start. Then Bill Fitch made a trade that would change the franchise when he sent Steve Patterson and Eric Fernsten to the Chicago Bulls for Nate Thurmond and Rowland Garrett. The acquisition of Thurmond and Austin Carr's return to health turned the season around. On April 10, 1976, a home win against the Knicks, with 14,326 fans in attendance and a national television audience watching, clinched what would be the Cavaliers' only Central Division title in the Coliseum era and set the stage for their first trip to the playoffs.

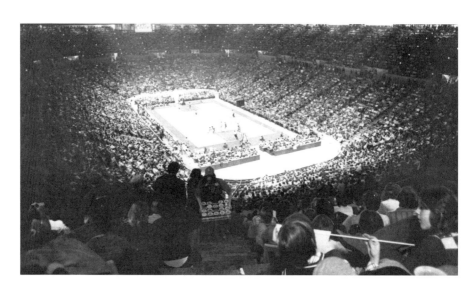

A record crowd of 21,130 watched the Cavaliers beat the Washington Bullets, 83–78, on February 8, 1976. *Courtesy the Cleveland Press Collection, Cleveland State University Special Collections.*

Sports Shrines from League Park to the Coliseum

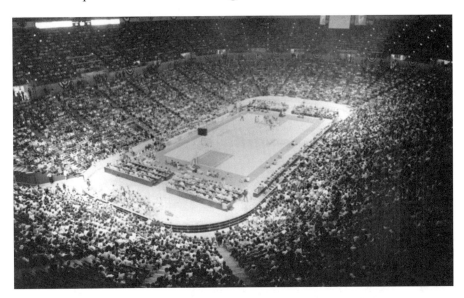

On April 13, 1976, the Cavaliers hosted their first playoff game. The Bullets beat the Cavs, 100–95, before 19,974 fans. The miracles were yet to come. *Courtesy the Cleveland Press Collection, Cleveland State University Special Collections.*

To fans outside of northeast Ohio, or those too young to have lived through it, a trip to the playoffs may seem too insignificant to merit a title such as the "Miracle of Richfield." After all, the Cavaliers were three playoff series away from the NBA title. Yet, the 1975–76 Cavaliers team played the signature season in the Coliseum era.

The Cavaliers opened the playoffs against the Washington Bullets on April 13, 1976, with a 100–95 loss at home in front of 19,974 fans. They evened the series two days later when Bobby "Bingo" Smith made a long jump shot with two seconds to go for an 80–79 win. They won game three at the Coliseum in relatively easy fashion, 88–76, as a then NBA playoff record crowd of 21,061 roared, but lost game four in Washington.

Game five at the Coliseum saw (in yet another new NBA record) 21,312 fans turn out to watch another miracle finish. Trailing 91–90 with seven seconds left, Washington star Elvin Hayes missed two foul shots, and Cleveland's Jim Brewer called time out after grabbing the rebound. As in the second game, Bingo Smith took another long jumper, but this time he shot an air ball. Jim Cleamons rebounded the miss and made a reverse layup as the buzzer sounded to give Cleveland a 3-2 series lead and a trip to Washington for game six. They lost in overtime, 102–98, and set the stage for the final game of the series at home.

On April 29, 1976, yet another playoff record crowd of 21,564 watched the teams battle to an 85–85 tie with twenty-four seconds to play. Fans erupted when Cavaliers guard Dick Snyder made a running bank shot to give Cleveland an 87–85 lead with four seconds left. When Nate Thurmond tipped a Washington inbounds pass into the corner and Phil Chenier missed a desperation jumper, the Cavaliers won the series. Fans rushed the floor and mobbed the players, but there was no threat or danger—just pure joy. The fans loved the Cavaliers and the players responded.

The Cavs would face the Boston Celtics next and fully expected to win the series and go on to the NBA Finals when the injury bug attacked. Center Jim Chones broke his foot during practice and was out for the rest of the playoffs. The Cavaliers lost a hard-fought series in six games. For each of the three home games, 21,564 fans were at the Coliseum screaming. During a time when scoreboards didn't plead for "Noise" or for fans to be "Louder," fans had to calculate the "Diff" on their own and mascots didn't wave flags, throw T-shirts into the stands or try to start rhythmic clapping, the fans at the Coliseum set a standard for cheering on their own. Long before playoff games started, the cheering and stomping rattled chalkboards in the locker rooms, and coaches had to shout to be heard over chants of "We want the Cavs!" and "Let's go Cavs!"

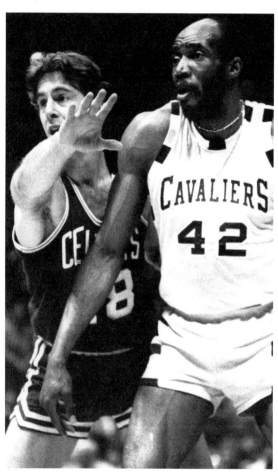

Nate Thurmond battles Dave Cowens during the 1976 NBA Eastern Conference finals. The Celtics won the series in six games. *Courtesy the Cleveland Press Collection, Cleveland State University Special Collections.*

Sports Shrines from League Park to the Coliseum

Years later, many of the players still believe that the Cavs would have won the NBA title if Chones had been healthy. Chones said, "I'll never forget those crowds at the Coliseum. They will never be like that again. These players today have no idea what it is like to be cheered by a crowd that is totally in love with you." Jim Brewer said, "I had never heard anything like that before. I've never heard anything like it since." Jim Cleamons said, "It was true joy and enthusiasm."

The fans' love for their team and the players' response to it, coupled with some amazing games, is what elevated the 1976 post-season to "Miracle of Richfield" status.

While the Cavs were playing their "Miracle" season, the Crusaders were playing their last. They finished the 1975–76 season in second place with a 35-40-5 record and lost in the first round of the playoffs to the New England Whalers.

Before the Crusaders left town, they hosted the 1976 WHA All-Star game on January 13, 1976. Gerry Cheevers and Paul Shmyr played for Team USA, but they lost to Team Canada, 6–1, with 15,491 fans in attendance. Shmyr was voted the Team USA MVP.

On March 10, 1976, the Crusaders took the ice wearing black armbands to protest talks between owner Jay Moore and the NHL. The players believed that General Manager Jack Vivian and Moore were trying to undermine the team and were plotting to move the Kansas City Scouts to Cleveland. The

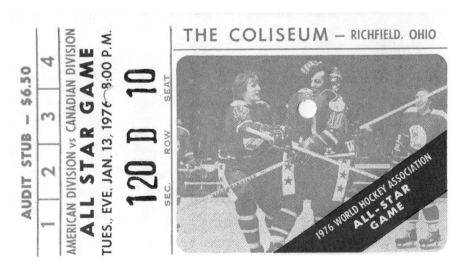

All-star hockey returned to Cleveland in 1976 for the first time since 1942, when the best of the WHA battled at the Coliseum. *Authors' collection.*

WHERE CLEVELAND PLAYED

Crusaders' public display of concern played out in front of 12,286 fans at the Coliseum. Jack Vivian resigned the next day, but the Crusaders were still doomed. They were transferred to Minnesota for the next season and folded on January 17, 1977.

Several other sports teams and leagues called the Coliseum home during the 1970s and 1980s. The National Hockey League (NHL), World Team Tennis (WTT), Arena Football League (AFL), Major Indoor Soccer League (MISL) and International Hockey League (IHL) all had teams at the Coliseum during that period.

With the Crusaders gone, the NHL finally tried hockey in Cleveland. Minority owner (and Clevelander) George Gund convinced owner Melvin Swig to relocate the California Golden Seals to Cleveland. The Seals had been a perennial loser during nine previous NHL seasons. With 18,544 seats for hockey, the Coliseum was the largest arena in the NHL. On October 6, 1976, the new Cleveland Barons battled the Los Angeles Kings to a 2–2 tie before just 8,899 fans. They got their first win three days later with only 5,209 in attendance.

The Barons' two-year stint in Cleveland was a challenging one. Besides financial problems, they were a public relations nightmare since fans never

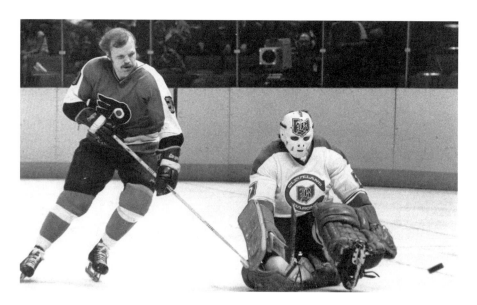

Goaltender Gilles Meloche guards the net against the Philadelphia Flyers' Bob Kelly at the Coliseum during the first season of the NHL Cleveland Barons. *Courtesy the Cleveland Press Collection, Cleveland State University Special Collections.*

Sports Shrines from League Park to the Coliseum

The Cleveland Nets were most successful in 1976, with player/coach Marty Riessen leading the team at the Coliseum. *Authors' collection.*

embraced the team. The Barons, led by Coach Jack Evans, finished last in the Adams Division in both the 1976–77 and 1977–78 seasons. That second season, the Barons played forty consecutive days without a victory and finished 22-45-13 with a 3–2 loss to Pittsburgh on April 9, 1978, at the Coliseum. After George and his brother Gordon Gund tried but failed to buy the Coliseum, the team merged with (and moved to) Minnesota in 1978. Dennis Maruk was the last former Baron to be active in the NHL when he retired after the 1988–89 season.

World Team Tennis was founded in 1973 and began play in 1974 with sixteen teams. After playing in 1974 at Public Hall, the Cleveland Nets moved to the new Coliseum in 1975, where they would remain until 1977. Tennis superstars Martina Navratilova (1976) and Björn Borg (1977) played for Cleveland, but the team and league struggled, drawing just 73,108 fans in 1976. By 1977, some "home" games were scheduled at neutral sites. The Nets moved to New Orleans in 1978.

The Major Indoor Soccer League (MISL) began play in Cleveland in 1978 as the Cleveland Force. After a tough first year, the Wolstein family bought the team from Eric Henderson. They acquired good players and put together a competitive team. Keith Furphy, Chris Vaccaro, Craig Allen and Kai Haaskivi made the team a force to be reckoned with. The team made seven playoff appearances but never won the championship.

On February 24, 1985, the Force and Coliseum hosted the MISL All-Star game. Allen, Furphy and Haaskivi all played for the victorious Western

WHERE CLEVELAND PLAYED

Tennis legend Martina Navratilova was early in her career when she played for the Cleveland Nets in 1976. *Courtesy the Cleveland Press Collection, Cleveland State University Special Collections.*

The Cleveland Force of the MISL in action in 1981. Goalie Cliff Brown defends a San Francisco attack. *Courtesy the Cleveland Press Collection, Cleveland State University Special Collections.*

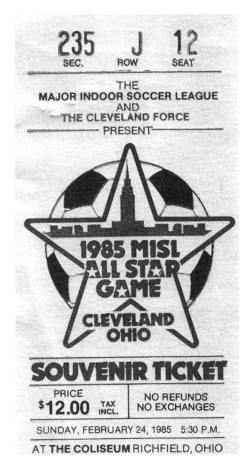

A sellout crowd of 17,863 watched the stars of the MISL at the Coliseum. The West beat the East, 11–7. *Authors' collection.*

Division. Baltimore's Stan Stamenkovic scored a hat trick and led the West to an 11–7 win in front of a sell-out crowd of 17,863.

An average of 14,111 fans watched Force home games during the 1986–87 season. The Force reached the championship series in 1988 but were swept by the San Diego Sockers four games to none. On July 22, 1988, the Force folded, citing a bleak financial outlook. While the Force had achieved success, the league was in trouble. The Cleveland Crunch replaced the Force in the MISL in 1989, but the league folded three years later and the Crunch joined the National Professional Soccer League (NPSL).

Arena football came to the Coliseum in 1992 when the Columbus Thunderbolts of the Arena Football League relocated to Cleveland after a winless 1991 season. The team didn't draw especially well, although a record 12,323 fans watched the game on May 30, 1992. The Thunderbolts finished

WHERE CLEVELAND PLAYED

Fans enter the Coliseum before a Cavaliers game. *Courtesy the Cleveland Press Collection, Cleveland State University Special Collections.*

4-6 and lost a playoff game. They were just 2-10 in each of the next two seasons and were disbanded after the 1994 season.

The Cavaliers had marginal success in the late 1970s but played one of the most exciting games in their history on January 29, 1980, winning a four-overtime game against the eventual champion Los Angeles Lakers, 154–153. Legendary Cavaliers voice Joe Tait called it one of the best games he had ever broadcast. Led by Mike Mitchell's thirty-four points, the relentless Cavs battled back numerous times to finally win the heart-stopping thriller in front of 13,820 fans.

Nick Mileti's financial problems prompted him to sell the Cavaliers, and after a series of new owners, Ted Stepien ended up in control of the team; unfortunately, the franchise was headed for the low period in its history. Joe Tait's honest appraisal of the team and criticism of Stepien, as well as the collapse of the team's radio deal with WWWE, meant that Tait would no longer be the broadcaster when the 1981 season ended. As the Cavaliers prepared to play the last home game of the season, something special was

Sports Shrines from League Park to the Coliseum

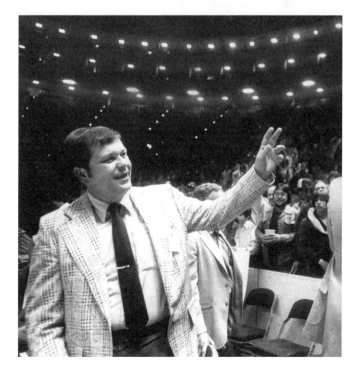

This page: Joe Tait greets fans (above) and waves to the crowd (right) after broadcasting his last home game for two years, a Cavs loss to Philadelphia on March 27, 1981. *Courtesy the Cleveland Press Collection, Cleveland State University Special Collections.*

happening. At the conclusion of a season in which there had not been a crowd of more than 10,000 at the Coliseum, 20,175 fans packed the building on March 27, 1981, to say goodbye and thank you to Joe Tait. Stepien refused to acknowledge Tait and insisted that the fans came to see the star-studded Philadelphia 76ers, who won easily, 138–117. Meanwhile, the crowd delighted in chanting "We want Joe" and "Stepien must go." Near the end of the game, after Stepien left the seating area to a shower of food and beer, Tait waved to the crowd, to a thunderous roar.

The real highlight of that season came on February 1, 1981, when the Cavaliers hosted the NBA All-Star game at the Coliseum. Cleveland's Mike Mitchell thrilled 20,239 hometown fans with fourteen points in fifteen minutes. Nate Archibald was the MVP as the East beat the West, 123–120.

Ted Stepien finally sold the Cavs to Coliseum owners George and Gordon Gund before the 1983–84 season. Having bought the Coliseum in 1981, the Gunds now owned the building and its primary tenant. Scoring machine

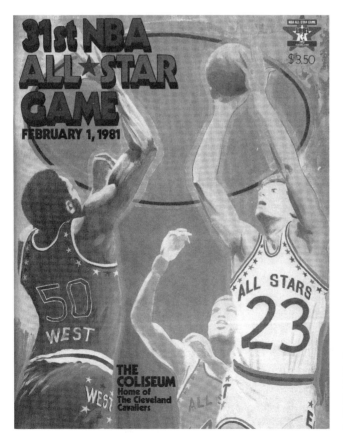

The Coliseum hosted its first and only NBA All-Star Game in 1981 with 20,239 fans in attendance. *Authors' collection.*

World B. Free joined the team and brought some excitement to Cavs games. Joe Tait returned to broadcast. Rookie coach George Karl led the team to a furious run to the playoffs in 1985. But it took a couple years for the team to really turn things around. In the summer of 1986, Wayne Embry was named general manager; he hired Lenny Wilkens to coach and named Gary Fitzsimmons as director of player personnel. The Cavs were headed for good times again. Players like Mark Price, Brad Daugherty, Ron Harper, Phil Hubbard, Craig Ehlo and John "Hot Rod" Williams led the team, but they finished the season just 31-51. The next year, they made the playoffs but lost a five-game series to the Chicago Bulls.

The 1988–89 season saw the Cavaliers post a 37-4 record at home, but it is playoff game five on May 7, 1989, in the opening round of the 1989 playoffs, that lives forever in Cavaliers history. Craig Ehlo scored on a layup to give Cleveland a 100–99 lead against Chicago with three seconds left in the series-deciding game, and the 20,273 roaring fans were reminiscent of the Miracle days. But three seconds was just enough time for Michael Jordan to hang in the air, nail a sixteen-foot jumper over Ehlo and torment Cavs fans with what is simply known as "The Shot." The Bulls won the game, 101–100, and the shocked silence that followed is almost as memorable as the roar it replaced.

The Cavaliers continued a successful run in the late 1980s and into the early 1990s. On December 17, 1991, they crushed the Miami Heat, 148–80. Cleveland actually led by seventy-three before the Heat scored the last five points to cut the deficit to sixty-eight—still the largest margin of victory in NBA history. In 1992, the Cavs reached the Eastern Conference Finals for the first time since 1976, but the Chicago Bulls were once again there to prevent them from competing for the NBA Championship.

The 1993–94 Cavaliers finished their last season at the Coliseum 47-35 (31-10 at home). They capped a franchise-record-tying eleven-game winning streak on March 8, 1994, with a home win against Sacramento and won their last regular season home game on April 24 by trouncing the Celtics, 117–91, in a sold-out Coliseum. But they faced the Bulls again in the playoffs.

Even without Jordan to torment them, Cleveland was swept in three straight games by Chicago. The last game on May 3 saw the Cavs' Chris Mills lead all scorers with twenty-five points (and ten rebounds), but Scottie Pippen led the Bulls to a 95–92 win before 17,778 fans. With that loss, the Cavaliers headed to the new Gund Arena (now Quicken Loans Arena) in downtown Cleveland.

The Cavaliers 1993–94 media guide featured the Coliseum and some of its greatest players and moments. *Authors' collection.*

Fourteen years after the NHL Barons played their last game, hockey returned to Cleveland and the Coliseum in 1992 when Larry Gordon moved his International Hockey League (IHL) Muskegon Lumberjacks to town. On October 10, 1992, the Coliseum welcomed 7,232 fans, who watched the Lumberjacks beat the Cincinnati Cyclones, 5–2. Perry Ganchar scored the first Lumberjacks goal in the first period. While there were no blocked pipes or slushy ice, there was a delay (almost an hour) when the lights blew out in the second period.

Sports Shrines from League Park to the Coliseum

Cleveland finished second in the Atlantic Division and was swept by Fort Wayne in the playoffs. The next year (the last at the Coliseum), the Lumberjacks finished last and missed the playoffs.

It has been reported that the last Coliseum event was a concert by Roger Daltrey on September 1, 1994. In reality, the Lumberjacks played their 1994–95 season exhibition at the Coliseum before moving to Gund Arena. In the last exhibition game, on September 24, 1994, the Lumberjacks lost, 5–4, to the expansion Detroit Vipers. Jock Callander scored the last goal at 16:42 of the third period.

With the Cavaliers and Lumberjacks playing in downtown Cleveland, the Coliseum sat empty. There was talk of turning the Coliseum into a megamall or a prison. Both would have been poor neighbors for the Cuyahoga Valley National Recreation Area (now the Cuyahoga Valley National Park). Eventually, the Trust for Public Land purchased the site and cleared the way to demolish the Coliseum. Independence Excavating was hired to do the job. The Coliseum was demolished from March to May 1999.

All that's left at the Coliseum site is a meadow that is part of the Cuyahoga Valley National Park. *Authors' collection.*

To alleviate vehicular congestion, a second entrance to the back of the Coliseum was added off Black Road. Today you can see the overgrown road and the trees that bordered the road into the parking lot. *Authors' collection.*

The Coliseum was not imploded. It was systematically disassembled. Much of the wood from floors and platforms was donated to charity to make toys for children. Outside lights, signs, guardrails and landscaping were removed, and the parking lot was scraped away. Loges and equipment were removed. Much of the steel framework was recycled as scrap.

Once the building was down, the rubble was covered with at least three feet of fill dirt and graded to the northeast. It is now a grassy meadow in the national park. Rare birds including bobolinks, eastern meadowlarks and Henslow's sparrows call the meadow home.

Today travelers along State Route 303 see no indication that the site once hosted some of the memorable events in Cleveland sports history, but for fans who were there, a look into the meadow makes the memories clear.

Cleveland Municipal Stadium

Cleveland was a big city with big ambitions in the 1920s. Cleveland could boast the 1920 world champion Indians in Major League Baseball and a 1924 championship team in the fledgling National Football League. League Park was a wonderful sports venue but also a small neighborhood ballpark.

To compete and hold its own with New York, Chicago and Los Angeles, Cleveland would need its own big stadium. The timing was right, and the place was Cleveland's lakefront. The idea to build a stadium on the lakefront, between West 9th Street and East 12th Street, surfaced in 1923. The idea advanced when William R. Hopkins became city manager (similar to mayor) in 1924, and Osborn Engineering Company created plans in 1926 for a facility similar in size and scope to the Los Angeles Memorial Coliseum. A big stadium would certainly have potential benefits to the Indians, who had the smallest seating capacity in Major League Baseball over at League Park.

On August 21, 1928, Cleveland City Council authorized a $2.5 million bond issue for the November ballot. The promotional campaign for the measure emphasized that a lakefront stadium would be a multipurpose venue that could hold sporting events and a wide variety of other entertainments. On November 6, 1928, Cleveland voters passed the measure, 112,448 to 76,975.

Construction of the stadium fell to Osborn Engineering and the architectural firm of Walker and Weeks, both based in Cleveland. Osborn had already engineered numerous sports facilities, including Fenway Park, Comiskey Park and Yankee Stadium.

Where Cleveland Played

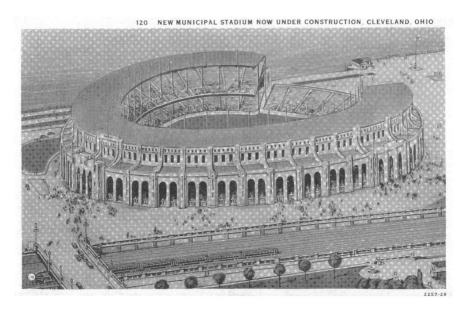

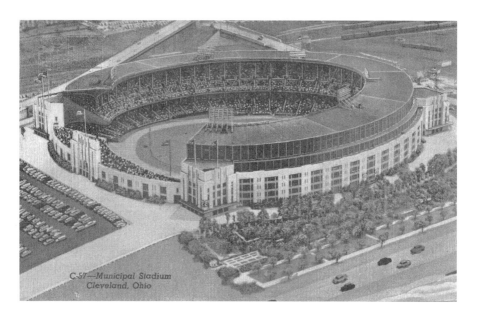

This page and next: Four postcard views of Cleveland Municipal Stadium show different angles and eras of the lakefront ballpark. *Courtesy the Rick Bradley Postcard Collection.*

Sports Shrines from League Park to the Coliseum

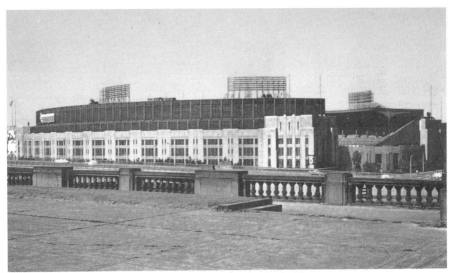

Municipal Stadium, Cleveland, Ohio

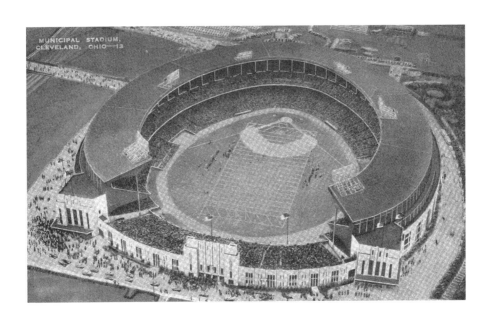

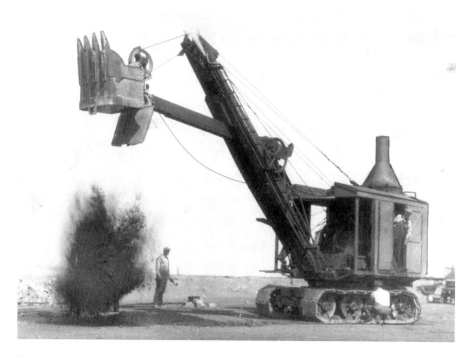

Construction begins on Cleveland Municipal Stadium. There was no ceremony. "Why celebrate?" was the comment of City Manager D.E. Morgan. *Courtesy the Cleveland Press Collection, Cleveland State University Special Collections.*

Excavating began unceremoniously in June 1930. During construction, tragedy struck on January 30, 1931, when two workers, Thomas Kelly and John Last, fell 115 feet and died on a particularly windy day. Just over a year after construction started, the stadium was finished well ahead of schedule for a cost of about $3 million.

The completed Cleveland Municipal Stadium was grand in every way. On July 2, 1931, more than eight thousand people paid twenty-five cents each to attend a civic opening. A huge chorus and several smaller ensembles performed. It was the largest stadium with individual (not bleacher) seating.

Fans could reach Cleveland Municipal Stadium via public transportation or automobile. Parking was available in lots and on nearby city streets south of the Stadium. Pedestrian approaches to the Stadium included West 3rd Street, East 9th Street, the ramps below Mall C and over the railroad tracks, leading fans to the south side of the Stadium between gates A and D.

Once inside the Stadium, seating sections were numbered from 1 to 43, from right field to left field, in both the lower and upper decks, with Section

Sports Shrines from League Park to the Coliseum

22 right behind home plate. The bleachers (eventual home of the "Dawg Pound") were numbered from Section 44 to Section 56.

Every section (except the bleachers) had poles. While the Stadium had some obstructed-view seats, there were more than enough unobstructed seats to handle most crowds. Seat colors changed over the years. Generally, red box seats were in front of the poles, and yellow reserved/mezzanine seats were behind the poles. A roof partially covered the upper deck seats. The Stadium was 115 feet tall.

By the time the Stadium opened on July 3, 1931, at 1085 West 3rd Street, with Max Schmeling successfully defending his heavyweight title against challenger Young Stribling, the stock market crash of 1929 had occurred and the Great Depression was unfolding. Just 36,936 fans showed up to see the fight.

The Stadium quickly became a venue for high school football games. Most notably, the Charity Game became an annual event at the Stadium starting on November 28, 1931.

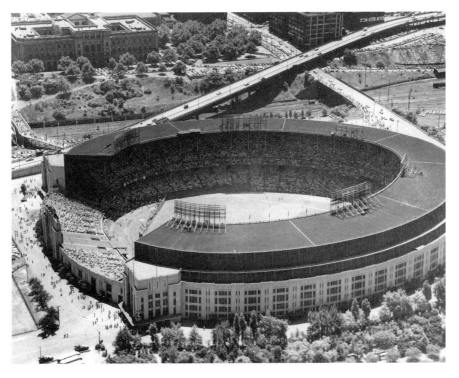

Gate C and the bleachers are at the open end of the Stadium. The park area at the bottom is the Donald Gray Gardens. *Courtesy the Cleveland Press Collection, Cleveland State University Special Collections.*

Where Cleveland Played

The Indians began play in the Stadium on July 31, 1932. The pitching matchup was Mel Harder of the Indians against Lefty Grove of the Philadelphia Athletics. Before 80,184 fans, Grove blanked the Tribe and Cleveland lost a 1–0 decision. The Indians played the remainder of the 1932 home schedule, and all of their 1933 home games, at the Stadium.

Johnny Burnett hit the first home run at the big ballpark on August 7, 1932, in the sixth inning of Cleveland's 7–4 win against Washington. Just a month earlier, on July 10, Burnett had a record nine hits in one game at League Park when the Indians lost to Philadelphia, 18–17, in eighteen innings.

By many measures, the first decade of Cleveland Municipal Stadium was a disappointment or worse. Cleveland's hopes of attracting the Summer Olympic games were never realized, but the city created its own event, the Great Lakes Exposition of 1936 and 1937. The exposition attracted some seven million people over its two years. It included the Donald Gray Gardens at the north side of the Stadium. The Gray Gardens were the only surviving element of the Great Lakes Expo when the Stadium was demolished in 1997.

When the Indians began play in the Stadium in 1932, it soon proved too big for the day-in and day-out needs of a Major League Baseball team. Attendance went from 468,953 in 1932 to 391,338 in 1933. The Indians moved in only to move back out to League Park following the 1933 season.

On the positive side, there was the 1935 Major League Baseball All-Star Game, just the third midsummer classic between the best players of the American League and the National League. The game drew 69,831 fans to see the AL win for the third straight year. Harder was one of the stars of a 4–1 victory. The attendance record stood until it was broken again in Cleveland in 1981. Major League Baseball at night came to Cleveland in 1939 after lights were installed at the Stadium. On June 27, Bob Feller pitched a one-hitter and defeated the Detroit Tigers, 5–0, in the first night game at the Stadium.

The climax of the bittersweet 1940 Indians season took place at the Stadium. In fact, all the Tribe home games in 1940 from August 18 until the end of the season took place at the big stadium on the lakefront. From a peak record of 69-44, the Indians lost fourteen of their next twenty-two games. But four wins in five games vaulted the Tribe above the Tigers again. After Al Smith beat the Senators, 3–1, at the Stadium on Thursday, September 19, Cleveland and Detroit were dead even on the verge of the three-game series in Detroit. Detroit fans taunted the Indians to the fullest. Baby bottles and baby carriages

played on the "Crybabies" nickname that had stuck to the 1940 Indians. The Tigers won twice and then extended their lead to two games before heading to Cleveland for the final weekend of the 1940 regular season.

Needing a three-game sweep to win the pennant, Oscar Vitt sent his ace, Bob Feller, to the mound on September 27. Detroit manager Del Baker decided that rather than use his ace, Lynwood "Schoolboy" Rowe, against Feller he would use rookie Floyd Giebell in only his second big-league appearance. With 48,533 fans (many of them unruly) in attendance, Giebell was, for one day, the equal of Feller. In the fourth inning, Feller walked Charlie Gehringer with one out but then struck out Hank Greenberg. Rudy York followed with a high fly down the left-field line. The ball barely eluded outfielder Ben Chapman's glove and dropped into the seats for a two-run homer, York's thirty-third homer of the year. Cleveland managed just six singles against Giebell and lost, 2–0. Instead of an all-Ohio World Series, it would be the Tigers against the NL champion Cincinnati Reds.

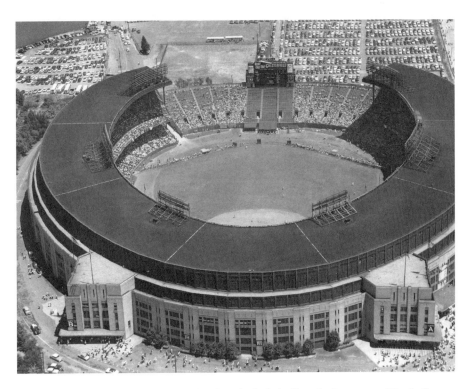

Gates A and B at the west end of the Stadium included offices for its tenants. The Indians occupied the Gate A tower and the Browns, the Gate B tower. *Courtesy the Cleveland Press Collection, Cleveland State University Special Collections.*

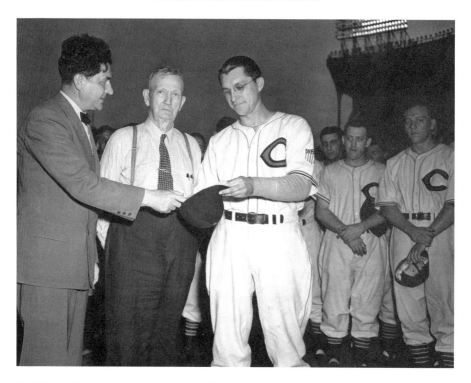

Mel Harder is honored at the Stadium. Cleveland mayor Frank Lausche presents Mel with a $1,000 war bond. Cy Young stands between Harder and Lausche. *Courtesy the Cleveland Press Collection, Cleveland State University Special Collections.*

One of the most memorable nights at the Stadium came in 1941 when Joe DiMaggio brought his fifty-six-game hitting streak over from League Park. On July 17, a record night game crowd of 67,468 saw two brilliant defensive plays by third baseman Ken Keltner and one by shortstop Lou Boudreau stymie the great DiMag.

During the 1940s, Cleveland Municipal Stadium was the stage for five pro football championship games in five straight seasons from 1945 through 1949, three games of the 1948 World Series and one game of the 1945 Negro Leagues World Series. During the decade, the Great Depression ended, the United States entered World War II, the war in Europe ended and the war with Japan ended. The end of World War II marked the beginning of a prosperous time in America, especially for the business of professional sports and its fans.

After Pearl Harbor was attacked, Bob Feller enlisted in the United States Navy. He did not return to the Indians until August 1945, sacrificing baseball

Sports Shrines from League Park to the Coliseum

Bob Feller returns from World War II. Feller had missed more than three and a half seasons, which may have cost him as many as one hundred wins and one thousand strikeouts. *Courtesy the Cleveland Press Collection, Cleveland State University Special Collections.*

glory to help America win the war. His return to Cleveland was a cause for civic celebration. His return to the Indians brought 46,477 fans to Cleveland Municipal Stadium on August 24. Robert was still "rapid." He retired twelve Detroit Tigers on strikeouts and defeated Hal Newhouser, 4–2.

The 1945 NFL Championship game was played at the Stadium on December 16 between the two best teams in the league: the 9-1 Western Division champion Cleveland Rams against the 8-2 Eastern Division champion Washington Redskins. Bob Waterfield's two long touchdown passes of thirty-seven yards to Jim Benton and forty-four yards to Jim Gillette and a safety generated just enough offense for Cleveland to hold off Washington, 15–14.

Within a month, the world champion Rams and the NFL left, heading west to Los Angeles. The Rams ceded the Cleveland territory to a new team in the new All-American Football Conference (AAFC).

Paul Brown (right), with Lou Saban, was the namesake and architect of the Cleveland Browns dynasty of the 1940s and 1950s. *Courtesy the Cleveland Press Collection, Cleveland State University Special Collections.*

The Cleveland Browns, led by Cleveland businessman Arthur "Mickey" McBride and Head Coach Paul Brown, began play in the AAFC in 1946 on September 6 against Miami. The Stadium crowd of 60,135 was almost twice that at the NFL Championship game of 1945. Cliff Lewis started at quarterback, but Otto Graham came in and passed for 109 yards, including a touchdown to Dante Lavelli. Lou Groza kicked three field goals, and Cleveland was off and running with a 44–0 shutout of the Seahawks.

In four AAFC seasons, the Browns won forty-seven of fifty-four games, including a perfect season in 1948. The Browns won all four AAFC title games, three at the Stadium. In 1946, the Browns beat the New York Yankees, 14–9, before 40,469 fans at the Stadium on December 22. In 1948, Cleveland capped its perfect season with a 49–7 defeat of Buffalo on December 19. Following the Barons' Calder Cup win in April and the Indians' World Series win in October, Cleveland was clearly the "City of Champions" with the Browns' victory, but only 22,981 fans came to the Stadium for the football championship.

By 1949, competition between the NFL and AAFC was hurting both operations. The AAFC cut back by one team and two regular season games. Nine wins gave Cleveland another trip to the AAFC title game on December 11, 1949, at the Stadium. A marquee matchup of two football powers, the Browns and the San Francisco 49ers, drew just 22,550 to the Stadium. Cleveland outdid the 49ers one more time with a 21–7 win. Both teams entered the NFL in 1950.

Sports Shrines from League Park to the Coliseum

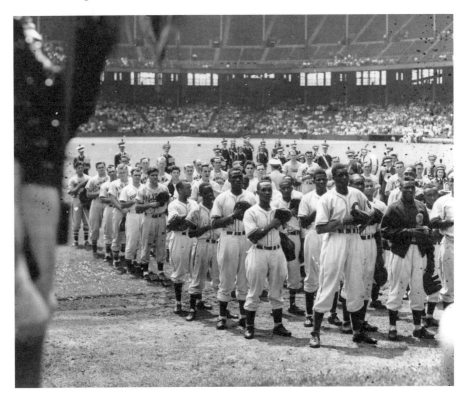

The Cleveland Buckeyes lead the way to center field for the flag-raising ceremony on Amateur Day in 1942 at Cleveland Municipal Stadium. *Courtesy the Cleveland Press Collection, Cleveland State University Special Collections.*

Bill Veeck came to Cleveland in 1946; he bought the Indians, integrated the American League by hiring Larry Doby in 1947, set attendance records and assembled the 1948 world champions of baseball.

More history was made at the Stadium on July 10, 1947, in the opener of a twin-bill against Philadelphia when Don Black pitched the first no-hitter in the big ballpark. Black's was the first of four Tribe no-hitters at the Stadium in its first forty years. Bob Lemon pitched a no-hitter against Detroit on June 30, 1948. Bob Feller pitched the third of his three no-hitters there on July 1, 1951 against the Tigers. Sonny Siebert pitched a no-hitter against the Washington Senators at the Stadium on June 10, 1966.

Besides making the permanent move to Cleveland Municipal Stadium, Veeck also decreed that there be an interior outfield fence, five feet high, to reduce the spacious Stadium outfield. Veeck went a little further and made

Larry Doby integrated the American League with the Indians in 1947, weeks after Jackie Robinson had integrated the Brooklyn Dodgers and the National League. *Courtesy the Cleveland Press Collection, Cleveland State University Special Collections.*

the fence portable. Groundskeepers would move it in or out depending on the opponent. The movable fence was outlawed the next year.

The interior fence greatly reduced the size of the Stadium outfield. Center field was shortened from 450 feet to 410 feet, and the power alleys were cut from 435 feet to 365 feet.

Veeck saw great potential in Cleveland and its big municipal stadium. Like a whirlwind, Veeck staged promotion after promotion and reenergized the Indians and Cleveland fans. He determined that, starting in 1947, the Indians would play all of their home games at the Stadium. He also set about building a championship ballclub.

The 1946 Indians won sixty-eight games, the fewest since 1928, but still set a club record attendance of 1,057,289. The 1947 Indians improved by twelve wins and set another club record by drawing 1,521,978 fans to the Stadium.

The 1948 Cleveland Indians season has yet to be matched. Lou Boudreau had the best season of his Hall of Fame career, and rookie knuckleball

pitcher Gene Bearden had a career year he never came close to duplicating. At the Stadium, it began with Feller's two-hit shutout of the St. Louis Browns before 73,163 fans (an opening-day record at the time) and Bob Lemon's no-hitter against Detroit. On July 7, Veeck signed Negro Leagues legend Satchel Paige. Criticized by some as a publicity stunt, the ageless Paige was spectacular in limited duty and critical to Cleveland's ultimate success.

A week later, the annual Amateur Day program at the Stadium took place to benefit the Cleveland Baseball Federation and local sandlot baseball. The 64,877 fans in attendance witnessed four immortals of Major League Baseball integration—Paige, Larry Doby, Jackie Robinson and Roy Campanella—all on the same field, along with other future Hall of Famers Boudreau, Joe Gordon and Pee Wee Reese.

There was Boudreau's dramatic pinch-hit on August 8. The injured player-manager limped off the bench to deliver a two-run game-tying single against the Yankees. Cleveland won the game and swept the doubleheader before 73,484 fans. There was the crowd of 78,382 (then a night game record) at the Stadium to see Paige shut out the White Sox, the fourth straight for Tribe pitchers, on August 20. In September, Doby's two-run homer in the ninth inning beat Philadelphia 5–3 on the nineteenth. On the twenty-second, Feller pitched a three-hitter for Cleveland's seventh straight win and a share of first place. Proceeds from the crowd of 76,772 went to benefit injured pitcher Don Black, who had suffered an aneurysm on September 13. There was also Joe Earley Night on September 28. Earley was given a variety of genuine and gag gifts in the ultimate tribute to the average fan. Cleveland then beat Chicago, 11–0. On Bill Veeck Day at the Stadium, October 3, 1948, the Tribe was poised to win the pennant, but Newhouser beat Feller before 74,181 fans.

After the 154 regular season games, Cleveland had a record home attendance of 2,620,627 and a still undecided pennant race. The Indians and Boston Red Sox had both won 96 games and were headed to Fenway Park for a one-game playoff.

By the time the Indians returned from Boston to Cleveland, the players were American League champions and had split the first two games of the 1948 World Series at Boston's Braves Field. Boudreau and Keltner powered an 8–3 win in the playoff game for Bearden's twentieth victory, but Cleveland mustered no offense against Johnny Sain in the World Series opener and lost, 1–0, despite Feller's two-hit pitching gem. Lemon's 4–1 win the next day evened the series.

The third, fourth and fifth games of the 1948 World Series drew 238,491 fans to the Stadium. Gene Bearden's shutout win gave Cleveland the series

lead in the third game before 70,306. The next day, Saturday, October 9, 81,897 fans saw another low-scoring nail-biter. Larry Doby's solo homer in the third inning was the deciding run in Cleveland's 2–1 victory. The photo of Doby and winning pitcher Steve Gromek hugging in the Stadium locker room after the game was another milestone in American race relations. It was also the last World Series victory for the Indians in Cleveland Municipal Stadium.

The biggest crowd yet (86,288) attended game five expecting Feller to wrap up the series, but Boston rallied for an 11–5 win. Back at Braves Field on Monday, October 11, the Indians won 4–3 and earned the right to fly the world championship pennant over Cleveland Municipal Stadium throughout the 1949 season.

The 1949 Indians could not recapture the magic of 1948. In its own way, though, the 1949 season was memorable, as names including Charlie Lupica (the flagpole sitter) and Johnny Barrows (the fictional "Kid from Cleveland") became part of Cleveland baseball lore.

Cleveland ascended through the baseball world in 1948, and the Indians proudly displayed both the American League and world championship pennants in 1949. *Courtesy the Cleveland Press Collection, Cleveland State University Special Collections.*

And then Veeck left, selling his interest in the Indians on November 21, 1949. Never again would the Indians take advantage of the giant Municipal Stadium in the same way, with the same combination of competition and carnival that Veeck brought to Cleveland.

During the 1950s, the Indians brought another World Series to Cleveland in 1954. The Browns moved from the AAFC to the NFL without missing a beat in 1950. Led by Head Coach Paul Brown and quarterback Otto Graham, the Browns went to ten consecutive championship games from 1946 to 1955.

The Rams returned to Cleveland on December 24, 1950, for the NFL Championship game. It was "Hollywood" against "the Best Location in the Nation." It was some game, though

The Cleveland Indians Flagpole Sitter 1949

Charley Lupica
Lupica Movers, Ltd.
362-1332

Cleveland teams have always had die-hard fans, but none more than Charlie Lupica, the infamous flagpole sitter of 1949. *Authors' collection.*

only 29,751 braved the Christmas Eve cold at the Stadium. Cleveland's offense, led by Graham, and the Rams, led by Waterfield, battled back and forth. With 1:50 remaining, Los Angeles led, 28–27. From his own thirty-two yard line, Graham drove the Browns forward with a run and three pass completions to the Los Angeles eleven. Groza lined up for the biggest kick in club history and calmly booted a sixteen-yard field goal. Cleveland 30, Los Angeles 28. The Browns were world champions of professional football.

The next year, the Rams got revenge. On December 23, 1951, at the Los Angeles Memorial Coliseum, they dethroned the Browns, 24–17. Cleveland returned to the NFL Championship game the next two years, only to lose both

Opened in 1952, the Cleveland Indians Hall of Fame in the lower concourse at Cleveland Stadium was a popular and memorable destination for many fans. *Courtesy the Cleveland Press Collection, Cleveland State University Special Collections.*

to the Detroit Lions—first at the Stadium on December 28, 1952, and again on December 27, 1953, in Detroit.

The Browns and Lions met on December 26, 1954, at the Stadium in a third straight championship game. This time, the Browns got revenge. Otto Graham took charge with three rushing touchdowns and three more passing in a glorious 56–10 rout of the Lions before 43,827 at the Stadium. Graham went out on top the next year, guiding Cleveland to a third NFL Championship by beating the Rams in Los Angeles.

In 1950, on June 23, Luke Easter hit the longest home run in Stadium history, a 477-foot shot into Section 4 in the upper deck in right field. Easter was one of many challengers to miss hitting a home run into the center-field bleachers. No one ever hit a home run into the bleachers, a distant 463 feet from home plate.

Inside the Stadium, the Cleveland Indians Hall of Fame opened in 1952. The Indians had established a Hall of Fame in 1951, the fiftieth anniversary of the franchise, with ten initial inductees. Over the years, the Indians Hall of Fame was a popular destination for fans at the ballpark and, for some, planted an interest in the team and its history that only strengthened the bond between the team and its fans.

In 1951, 1952 and 1953, the Indians were agonizingly close to another American League pennant. An early September slump likely cost the '51 team a crown. The '52 Tribe won nine straight games in early September to close within a half game of the Yankees, only to fall two and a half

Sports Shrines from League Park to the Coliseum

games back when Eddie Lopat beat Cleveland for the thirty-fifth time to frustrate a Stadium crowd of 73,609 (largest of the season) on September 14. The Indians won nine of the next ten games and still finished two behind the Yankees. The following season had a dramatic finish at the Stadium, even though the pennant race had been decided on September 14. On the final day of the season, Al Rosen led the American League in home runs and RBIs but trailed Mickey Vernon by three percentage points in the batting average race. When Al came to bat with two out in the bottom of the ninth, he had three hits and needed one more to win the Triple Crown. On a 3-2 pitch, Rosen hit a slow bouncer to third baseman Jerry Priddy. Priddy's throw beat Rosen by a step and denied him the Triple Crown. The game against the Tigers was also Jack Graney's last as a broadcaster for the Indians.

The Indians finally brought a pennant back to the Stadium in 1954 with one of the great seasons in baseball history. Cleveland's great pitching and power hitting kept the Tribe ahead of the Yankees into September and up to a series at the Stadium. On September 12, 84,587 (paid) fans packed the Stadium for a sweep of the Yanks as Bob Lemon and Early Wynn got the victories. After clinching the pennant in Detroit, the Indians iced the regular season with an 11–1 win at the Stadium on September 25. Wynn's two-hitter gave Cleveland an American League record 111 wins, one more than the 1927 Yankees. Even so, home attendance (1,335,472) was barely more than half the 1948 total.

The Stadium also hosted its second Major League Baseball All-Star game in 1954. Bobby Avila, Doby, Al Rosen and Lemon represented the Tribe in an exciting contest on Tuesday afternoon, July 13. Rosen was the top vote getter in fan balloting and responded with two home runs and five RBIs as the starting first baseman. Doby homered in the eighth inning to tie the game, 9–9. Nellie Fox delivered the game-winning hit, a two-run bloop single to give the Americans an 11–9 victory before 68,751 fans.

As in 1948, the Indians fought off one team for the pennant and another from the same city in the World Series. As in 1948, the series began away from Cleveland. As in 1948, the first game was a heartbreaking Tribe loss. Two of the most memorable moments in World Series history—Willie Mays's sensational catch of Vic Wertz's blast and Dusty Rhodes's short, game-winning home run—happened in Cleveland. In 1954 the Indians also lost the second game before returning home.

On Friday, October 1, 1954, the World Series was back in Cleveland, with 71,555 fans in attendance. The Indians lost again. The next day, before

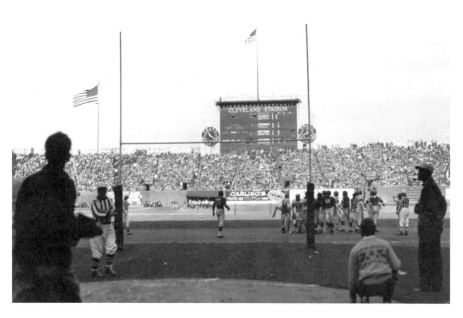

Lou Groza scores 3 of his 1,608 points in a 1952 game against the New York Giants at the Stadium during another championship season for the Browns. *Courtesy the Cleveland Press Collection, Cleveland State University Special Collections.*

78,102 fans, the Giants completed a stunning four-game sweep. It was the final World Series game ever played at Cleveland Municipal Stadium.

Of the many stars to play for Cleveland at the Stadium in the 1940s and 1950s, Bob Feller of the Indians and Otto Graham of the Browns rank at the top. An era ended when Graham retired after the 1955 NFL Championship game, and Feller did the same after the 1956 Major League Baseball season.

The Indians had a clear heir apparent to Feller in young left-handed pitcher Herb Score. Score was Rookie of the Year in 1955 and a twenty-game winner in 1956, leading the big leagues in strikeouts both seasons.

It seemed that only tragedy could keep Score from greatness. On the night of May 7, 1957, tragedy struck. In the first inning, Gil McDougald faced the Cleveland lefty. McDougald hit a line drive up the middle, striking Score in the face. He escaped with his life and his sight but never again dominated batters as he had in 1955 and 1956.

Score did rally to help Cleveland battle for another pennant in 1959. With Rocky Colavito leading the offense, the Indians battled the Chicago White

Sports Shrines from League Park to the Coliseum

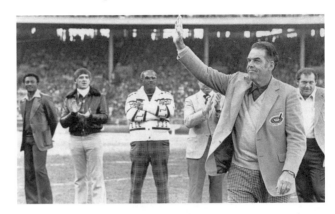

Otto Graham (waving), championship quarterback of the Browns from 1946 to 1955, is honored at the Stadium. Also honored are Paul Warfield, Dick Shafrath, Marion Motley and Gene Hickerson. *Courtesy the Cleveland Press Collection, Cleveland State University Special Collections.*

One of the darkest days at Cleveland Municipal Stadium was May 7, 1957. Herb Score is carried off the field after being hit by Gil McDougald's line drive. Score never again matched his pitching success of 1955 and 1956. *Courtesy the Cleveland Press Collection, Cleveland State University Special Collections.*

Sox into September for the American League pennant. Attendance more than doubled to 1,497,976, highest at the Stadium since 1951. With the possible exception of 1974, the Stadium had hosted its last pennant race featuring the Indians.

After a down year in 1956, the Browns drafted legendary running back Jim Brown and returned to the NFL title game in 1957. Brown embarked on a career that included eight rushing championships in nine record-setting seasons, 12,312 total rushing yards, 106 rushing touchdowns and 756 points scored. Brown rushed for over 100 yards in a game fifty-eight times, four times surpassing 200 yards. He was Rookie of the Year in 1957, NFL MVP in 1958 and 1965 and a nine-time Pro Bowl selection. With Jim Brown leading the offense, the Cleveland Browns finished first or second in the NFL Eastern Conference seven times.

Rocky Colavito's status as Cleveland's baseball icon of the 1950s and 1960s is evident on picture day in 1967. He was voted as most memorable personality in Tribe history in 1976. *Courtesy the Cleveland Press Collection, Cleveland State University Special Collections.*

In 1958, it was the Browns a win away from another title game. In 1959, it was the Indians finishing a close second to the American League champion White Sox. The bar had been set high at Cleveland Municipal Stadium. In fifteen years, the "Lady on the Lake" had hosted championship games and pennant-contending teams on an annual basis. The decades ahead would be much different.

The 1960s at the Stadium began with the Indians' home opener against the Detroit Tigers. Two days earlier, "the curse of Rocky Colavito" was born when Cleveland's home run champion was traded to Detroit for its batting champion Harvey Kuenn.

Even with Jim Brown, the dominant football figure in Cleveland entering the 1960s was Paul Brown. That changed on March 21, 1961, when Art Modell led a syndicate in purchasing the team from the David Jones group for almost $4 million.

In 1962, Modell initiated the football doubleheader at Cleveland Municipal Stadium. Labeled "A Festival of Football," the Pittsburgh Steelers, Detroit Lions and Dallas Cowboys all traveled to Cleveland, and 77,683 fans saw the Lions beat the Cowboys before the Browns trounced the Steelers, 33–10, on August 18. The doubleheader became an annual preseason event at the Stadium for more than a decade.

Sports Shrines from League Park to the Coliseum

It's surprising that Cleveland Municipal Stadium withstood the shockwaves in 1963 when Modell fired Paul Brown as head coach on January 7. Reaction was mixed, but many vilified Modell for his action.

The Indians hosted another Major League Baseball All-Star Game in 1963. Only 44,160 fans turned out on Tuesday afternoon, July 9, to cheer on the stars, including Cleveland pitcher Jim "Mudcat" Grant, who was not even used by American League manager Ralph Houk. Willie Mays was chosen Most Valuable Player of the National League's 5–3 triumph.

Change was a constant for the team throughout the 1960s. Ted Williams's home run off Wynn Hawkins on June 17, 1960, at the Stadium was the 500th of his career. On July 31, 1963, Woody Held, Pedro Ramos, Tito Francona and Larry Brown hit a record four consecutive home runs off Paul Foytack of the Los Angeles Angels.

The team was good enough to be courted by cities including Oakland and Seattle. Without a promoter like Bill Veeck, without a championship team

The Browns tied St. Louis in the 1964 home opener en route to the NFL Championship. Paul Warfield (42) and Leroy Kelly (far left) were two of Cleveland's offensive mainstays. *Courtesy the Cleveland Press Collection, Cleveland State University Special Collections.*

Where Cleveland Played

and in a city on the downturn in population, prestige and productivity, the Indians were once again in too big a ballpark that was too empty too often.

By 1964, it had been six straight seasons without an NFL title game at the Stadium. The Browns had fallen into a bridesmaid's role behind the New York Giants, finishing second to the Giants in 1958, 1959 and 1963 and third to New York in 1961 and 1962. But in 1964, the St. Louis Cardinals were Cleveland's only serious challenger for the conference title. A great offense, led by Jim Brown, quarterback Frank Ryan, rookie receiver Paul Warfield and third-year receiver Gary Collins fueled ten wins in fourteen games and a trip back to the title game against the 12-2 Baltimore Colts, winners of the Western Conference.

On December 27, 1964, the Browns engineered one of football's greatest victories. After a scoreless first half, Lou Groza kicked two field goals, and Ryan delivered three long touchdown passes to Collins. Baltimore's Hall of Fame quarterback Johnny Unitas was held in check by the Cleveland defense. At the end, Cleveland won a spectacular and unexpected 27–0 rout and the fourth NFL Championship in franchise history.

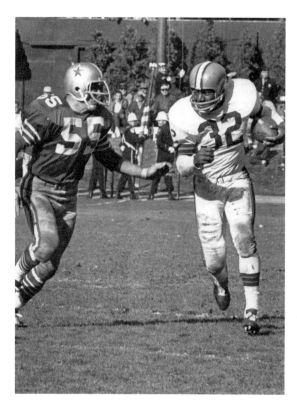

Jim Brown (32), arguably the greatest running back in pro football history, led the Browns to the 1964 NFL Championship. *Courtesy the Cleveland Press Collection, Cleveland State University Special Collections.*

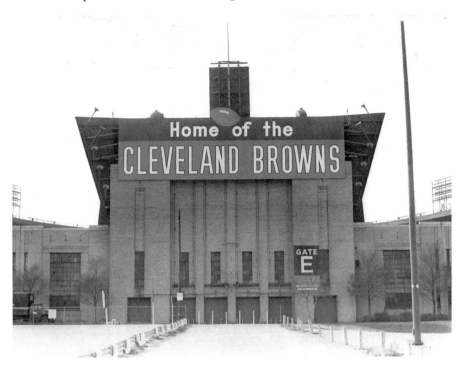

Gate E, as it looked in 1965 when the Browns were defending NFL champions, was located at the open end of the Stadium behind the bleachers. *Courtesy the Cleveland Press Collection, Cleveland State University Special Collections.*

The young owner, Art Modell, was vindicated by the 1964 NFL season. Jim Brown had his championship. Modell and his head coach, Blanton Collier, had escaped the shadow of Paul Brown. Cleveland was back on top.

Hollywood returned to the Stadium in 1965, this time with an A-list film helmed by Academy Award–winning director Billy Wilder. *The Fortune Cookie* begins at the Stadium during a 1965 game between the Browns and the Minnesota Vikings. Walter Matthau's plum role as "Whiplash" Willie Gingrich earned him an Academy Award. Like *The Kid from Cleveland*, the film is a civic treasure with its scenes of Terminal Tower, the Stadium and other local locations.

In 1965, two Cleveland greats sparkled at the Stadium one last time. First, Colavito returned and had a standout season, leading the American League with 108 RBIs. His return also helped increase home attendance to 934,786 and reduced concerns that the Indians would move.

Jim Brown then staged another great campaign, leading the Browns to another conference title. Green Bay finally dethroned the champions with a

Jack Lemmon stands in Section 26 of Cleveland Municipal Stadium during filming of Billy Wilder's *The Fortune Cookie* in November 1965. *Courtesy the Cleveland Press Collection, Cleveland State University Special Collections.*

win in the mud at Lambeau Field. Brown retired to pursue an acting career and other interests.

History has seemed to little note, nor long remember, that the Browns of the 1960s came within one win of Super Bowl III and Super Bowl IV. Great upset victories over the Dallas Cowboys were overshadowed by crushing defeats to the Baltimore Colts in the 1968 NFL Championship game and the Minnesota Vikings in the 1969 NFL Championship game.

The following season began with another legendary Stadium event. ABC Sports and its broadcasting trio of Howard Cosell, Keith Jackson and Don Meredith came to Cleveland on September 21, 1970, for the debut of ABC's *Monday Night Football*. Star quarterback Joe Namath and the Super Bowl III–winning New York Jets were the opponents. Browns quarterback Bill Nelsen, whose bad knees were equal to or worse than those of the celebrated Namath, hit Gary Collins with a touchdown pass, Bo Scott rushed for another score and Homer Jones returned the second-half kickoff ninety-four yards for

Howard Cosell came to Cleveland Municipal Stadium in 1970 for the first *Monday Night Football* game and several others, including the 1980 game between the Browns and the Houston Oilers. *Courtesy the Cleveland Press Collection, Cleveland State University Special Collections.*

a touchdown. Linebacker Billy Andrews intercepted a Namath pass and returned it twenty-five yards for the final touchdown in Cleveland's 31–21 victory before 85,703 fans at the Stadium and a national television audience.

As the 1970s approached, the Stadium was becoming a drain on Cleveland's budget. The population was declining, which led to fewer tax dollars. City Council president James Stanton pushed for the Stadium to be leased to a private enterprise. Several potential concerns offered plans to run the Stadium operations. Ultimately, Art Modell's newly formed Stadium Corporation contracted to lease the Stadium for twenty-five years in October 1973.

Before Modell rescued the Stadium, Nick Mileti rescued the Indians. It could have been George Steinbrenner. The story of Steinbrenner's bid for the Indians is well told in *Endless Summers: The Fall and Rise of the Cleveland Indians* by Jack Torry. A deal between Vernon Stouffer, who bought the team in 1966, and Steinbrenner's group seemed to be at hand until Stouffer backed out.

A complex agreement required the Stadium Corporation to spend at least $10 million on much-needed improvement during the first ten years of the lease. The Stadium Corporation gained control of the Stadium in 1974 and immediately invested $3.6 million to build 108 loges. The eight- or ten-seat loges were tucked under the upper deck and seated more than one thousand people, but the real advantage was the $10,000 to $15,000 each one generated. The loges were a hit with Cleveland businesspeople, and all 108 loges were sold from 1975–93. (The most expensive loges cost $59,000 by 1993.)

After the 1975 Browns season, the playing field was lowered by thirty inches to improve sightlines. The slope of the field was also adjusted. New and improved drainage tile was installed, and new grass was planted. After the next season, the field was torn up again and more drainage tile was installed. Since the Stadium was used for both football and baseball, new sod was installed almost every year—the grass never really had a chance to root correctly, and players would sometimes slip on the loose sod.

In 1978, the largest (at the time) scoreboard in a sports facility was installed at a cost of $1.5 million. The new matrix board had both message and animation capability. New plumbing, wiring, elevators and concession stands were added during the next few years, and by 1982 the Stadium Corporation had already spent more than the required $10 million.

While the 1970s saw improvements to the Stadium, the Indians and Browns struggled. Even a move to the American Football Conference of the expanded National Football League, after its merger with the American Football League, could not help the Browns remain a playoff team in 1970, when Paul Brown enjoyed the sweet revenge of guiding his Cincinnati Bengals past Modell's Browns. The Browns missed the playoffs from 1973 to 1979. The Indians never finished higher than fourth in the new six-team (after 1977, seven-team) American League eastern division from 1969 to 1993. The Stadium was more than ever known as "the Mistake on the Lake."

In 1971, the Indians were 60-102. They would lose at least one hundred games again in 1985, 1987 and 1991. (In 1986, an 84-78 record made them the only team to sandwich one-hundred-loss seasons around a .500+ campaign.) Even though they finished over .500 just five times from 1969 to 1993, there were some notable events.

The Indians acquired future Hall of Fame pitcher Gaylord Perry and shortstop Frank Duffy for Sam McDowell on November 11, 1971. Perry was 24-16 in a Cy Young Award–winning season in 1972.

Typically, the Indians would draw a big opening-day crowd and then struggle. In 1973, total attendance for the Indians was just 605,073. The crowd of 74,420 on April 7 set a major league record for opening-day attendance. The Browns had similar trouble, as home attendance declined for six consecutive years from 1970 to 1975.

Perry won nineteen in 1973 and twenty-one in 1974 when, after losing on opening day, he ran off a fifteen-game winning streak. On June 28, 1974, a crowd of 33,020 watched Perry defeat Boston, 2–1, for his fourteenth consecutive victory. George Hendrick doubled home Leron Lee, who scored by crashing into Carlton Fisk. The streak ended in Oakland on July 8 with a tenth-inning 4–3 loss.

On June 4, 1974, one of the more embarrassing moments in Indians and Stadium history occurred when an ill-conceived promotion—10-cent Beer Night—went awry. A crowd of 25,134 (nearly double the average attendance) bought tickets not just to see a baseball game but also to get plastered on cheap beer.

Fueled by the media's promotion of a rematch with Texas—whose own Beer Night the week before led to a brawl between the same two teams on the field—and the ten-cent beer, "fans" began to get out of control. M-80 firecrackers were exploded in the upper deck. By the sixth inning, drunken fans began to run onto the field. A streaker slid into second base.

While few fans in attendance seemed to care, the Indians rallied to tie the game in the ninth inning, 5–5. With the bases loaded and two outs, Rangers pitcher Steve Foucault tried to end the inning, but a fan ran toward right-fielder Jeff Burroughs, tried to snatch his hat and glove and shoved him. Burroughs chased the fan as hundreds more fans rushed the field.

Texas manager Billy Martin led a charge of players from the dugout to help Burroughs. Indians players ran onto the field to aid the Rangers and soon found themselves under attack as well. Ultimately, umpire Nestor Chylak forfeited the game to the Rangers.

There were only nine arrests in the incident, and only Indians pitcher Tom Hilgendorf was seriously hurt. He was struck in the head by a flying chair and had to be helped from the field.

On July 19, 1974, Dick Bosman pitched a no-hitter at the Stadium and defeated Oakland, 4–0. On September 12, the Indians acquired Frank Robinson in a trade with the Angels, and less than a month later, on October 3, 1974, he was introduced as the Indians' new manager, replacing Ken Aspromonte. Robinson would still be a player (becoming the sixth player-manager in Indians history and the first since Lou Boudreau in 1950), but more

Where Cleveland Played

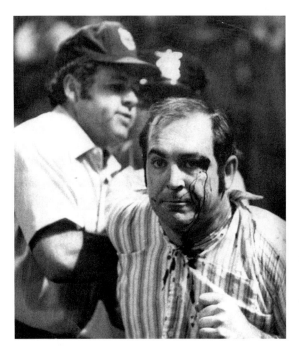

Umpire Joe Brinkman restrains an agitator during the ten-cent beer night riot on June 4, 1974. According to *Texas Rangers* by Eric Nadel, Jim Sundberg identified this fan as the instigator who charged Jeff Burroughs and accelerated the melee. *Courtesy the Cleveland Press Collection, Cleveland State University Special Collections.*

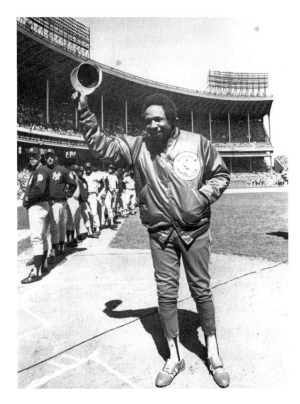

Frank Robinson acknowledges the crowd on opening day 1975 before managing the Indians against the New York Yankees. *Courtesy the Cleveland Press Collection, Cleveland State University Special Collections.*

significantly, he would be the first black manager in the major leagues. While General Manager Phil Seghi said that he was hiring the best man available, CEO Alva "Ted" Bonda said, "We needed somebody to wake up the city."

Frank Robinson's famous managerial debut on April 8, 1975, was highlighted by his own first-inning home run. As the designated hitter in the Indians' lineup, Robby batted second and ripped a home run off George "Doc" Medich to left-center-field. Robinson said after the 5–3 win that "right now I feel better than I have after anything I've done in baseball."

Unfortunately, Robinson could not really change the Indians' fortunes. They finished 79-80 but had some good performances by rookies Dennis Eckersley, Duane Kuiper and Rick Manning in 1975. The next year, the Indians climbed over .500 and finished 81-78. A series against the Yankees drew more than 200,000 to the Stadium, but the Tribe lost three of four games. Robinson's last at bat in the major leagues came on September 18 when he collected a pinch single.

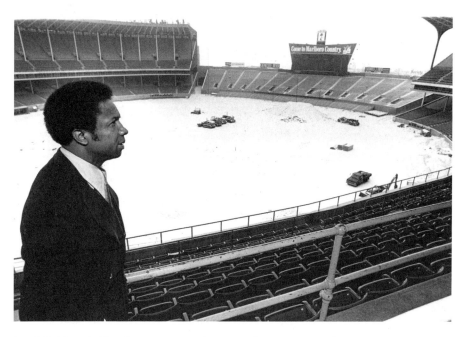

Frank Robinson's historic tenure managing the Indians lasted into the 1977 season, just 375 games. *Courtesy the Cleveland Press Collection, Cleveland State University Special Collections.*

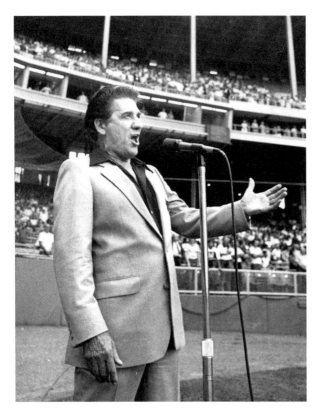

Left: Rocco Scotti's booming voice singing the national anthem was a regular part of the Cleveland Stadium scene during the 1970s and 1980s. *Courtesy the Cleveland Press Collection, Cleveland State University Special Collections.*

Below: Grandstand Managers games at the Stadium provided fans with a free ticket upon request. "Chief Second Guesser" Hal Lebovitz was sports editor of the *Cleveland Plain Dealer* and is a member of the writer's wing of the National Baseball Hall of Fame. *Authors' collection.*

1978 THE PLAIN DEALER GRANDSTAND MANAGERS ASSOCIATION

E. Pluribus Second Guessum

This certifies that _____ is a member in good standing for 1978 and the Plain Dealer Grandstand Managers Association and entitles said member to second guess anybody, including wife or husband, as the case may be about any thing on any and all occasions.

MEMBERSHIP CARD

Hal Lebovitz
CHIEF SECOND GUESSER

Sports Shrines from League Park to the Coliseum

Robinson entered the 1977 season as the manager but was fired on June 19 after a slow start and replaced by Jeff Torborg. Three weeks earlier, on May 30, Dennis Eckersley pitched a no-hitter in a 1–0 win against California. Newly acquired Andre Thornton led the team with twenty-eight homers, but free agent Wayne Garland's injured shoulder led him to a 13-19 record. He retired in 1981, just halfway through his ten-year, $2.3 million contract.

"Super Joe" Charboneau burst onto the scene and was the 1980 American League Rookie of the Year. After hitting two home runs in the home opener in front of 61,573 fans, Charboneau became a phenomenon. Unfortunately, a back injury curtailed his career, and by 1982 his time in the major leagues was over. Charboneau is still a popular figure in northeast Ohio.

Cleveland Municipal Stadium was scheduled to host the Major League Baseball All-Star Game on July 14, 1981, but a players strike on June 12 threatened the game. When the strike was settled at the end of July, Major League Baseball determined that after a week of "spring training," baseball would kick off its return on August 9 with the all-star game at Cleveland. A record 72,086 fans watched Gary Carter hit two home runs and lead the

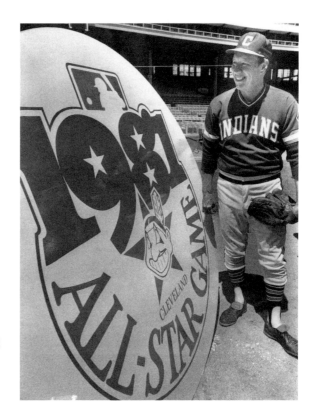

Bob Feller poses with the 1981 All-Star Game logo. The game was postponed from July 14 until August 9 due to a players strike but still drew a record attendance of 72,086. *Courtesy the Cleveland Press Collection, Cleveland State University Special Collections.*

NL to a thrilling 5–4 victory. It was the record fourth all-star game at the Stadium. More than 250,000 fans saw all-star baseball in the four games.

The other highlight that year came less than a month before the strike, when Indians pitcher Len Barker threw just the eighth modern-era perfect game on May 15. On a dreary night, Barker dominated the Toronto Blue Jays and struck out eleven in the 3–0 gem. Ernie Whitt's fly ball to centerfielder Rick Manning sealed the victory before 7,290 fans.

The Indians weren't the only Stadium tenant to endure a difficult decade. The Browns continued to slip from the high standards of the previous generation. In 1974, a 4-10 record was just the second sub-.500 season in their history. By 1975, just over 390,000 fans attended home games.

On October 10, 1976, Browns end Joe "Turkey" Jones, playing the game of his career, against the arch rival Pittsburgh Steelers, sacked Steelers quarterback Terry Bradshaw. It was no ordinary sack. Jones lifted Bradshaw and drove him headfirst into the ground. Bradshaw sustained a bruised spinal column and did not return to the game. The crowd roared. Jones received a fifteen-yard unnecessary roughness penalty, and the Browns went on to win, 18–16, and start a streak of eight wins in nine games—but it was not enough to reach the playoffs.

The Browns' fortunes started to turn in 1978 when Sam Rutigliano was hired to coach. Quarterback Brian Sipe became a starter in 1976 and blossomed under Rutigliano. In 1979, the Browns finished 9-7, and the "Kardiac Kids" were coming together; the stage was set for 1980, when the Browns were 11-5 and won the Central Division title.

It wasn't just that the Browns won, it was how they won, that earned the moniker "Kardiac Kids." They were never out of a game. With offensive weapons Ozzie Newsome, Mike Pruitt and Reggie Rucker at his disposal, AFC Player of the Year Sipe set records for passing yardage (4,132) and touchdowns (thirty). More than half of the games were decided in the last two minutes.

A record 620,496 fans attended the eight home games with thoughts of going to the "Siper Bowl." The Browns' playoff game against the Oakland Raiders on January 4, 1981, drew 77,655 to the Stadium despite near zero temperatures and wind chills reported as low as minus-forty degrees. The field was frozen and slippery, and the teams battled each other as well as the elements just to move the ball.

The Browns trailed 7–6 at halftime and took a 12–7 lead in the third quarter but trailed 14–12 when they got possession at their own fifteen with 2:22 remaining in the fourth quarter. With less than a minute to go, the

Sports Shrines from League Park to the Coliseum

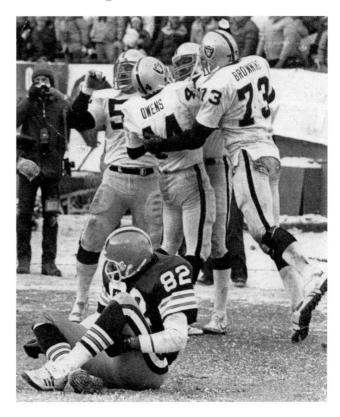

Ozzie Newsome (82) sits in the end zone as Oakland celebrates Mike Davis's interception to end the Browns' drive and one of their most exciting seasons on January 4, 1981. *Courtesy the Cleveland Press Collection, Cleveland State University Special Collections.*

Browns had moved the ball to the Oakland thirteen. During a time out, Rutigliano decided to forego a field goal attempt, since kicker Don Cockroft had already missed four of six kicks in the horrible field conditions. He called a pass play, "Red Right 88." Sipe was instructed to throw the ball "into Lake Erie" if the receivers were covered. Dave Logan was the intended receiver, but as the defense reacted to the play, Ozzie Newsome broke to the left side of the end zone and Sipe thought he was open. Oakland safety Mike Davis lunged in front of Newsome and intercepted the pass in the end zone. (It turned out that Logan was open after Dwayne O'Steen left him to double-team Newsome.) As with the Cavaliers in 1976, the miracle was over, and the frozen, dejected Browns fans trudged back to their cars for a long trip home.

The Indians marched through the 1980s with little success, but in 1986 they led the American League in batting (.284) and runs (831). Pitcher Greg Swindell arrived after a couple months in the minors and started his first game on August 21. By the time the game ended, Boston's Spike Owen had

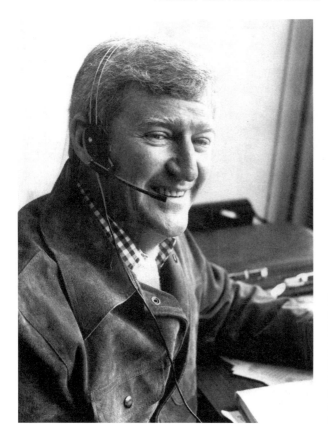

Herb Score was the companion of Tribe fans on broadcasts from 1964 to 1997. He was on radio from 1968 until the final at-bat of the 1997 World Series. *Courtesy the Cleveland Press Collection, Cleveland State University Special Collections.*

tied the major league record by scoring six runs (while batting ninth no less), and Boston won, 24–5. Swindell finished 5-2, while the team was 84-78.

Coming off the promising 1986 season, the Indians were the trendy team to pick to win a pennant in 1987. They were featured on the April 6, 1987 cover of *Sports Illustrated* with the proclamation "Believe It! Cleveland Is the Best Team in the American League." They promptly lost 101 games.

Still, good things were happening in the front office. In 1986, the F.J. "Steve" O'Neill estate sold the team to David and Richard Jacobs. The Jacobs ownership brought stability to the organization. Hank Peters was hired to run the baseball operation. John Hart was added to the management team in 1989. The Indians continued to struggle on the field, losing a team record 105 in 1991. The year before, Cuyahoga County voters had passed a cigarette and alcohol tax to fund a new stadium and arena in downtown Cleveland. The Indians' days at Municipal Stadium were numbered.

Sports Shrines from League Park to the Coliseum

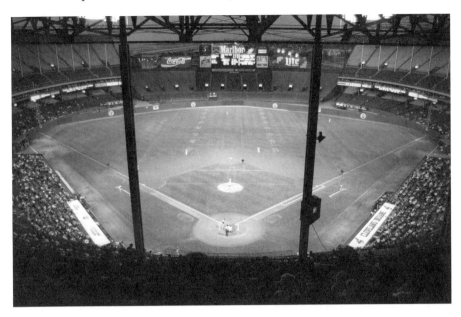

The view from behind the plate, posts and all, shows the football grid over the baseball field during an Indians game in September 1993. *Authors' collection.*

As the baseball pennant drought at the Stadium stretched to thirty-five years, a championship club emerged in fictional form in the film *Major League*. Starring Tom Berenger, Corbin Bernsen, Charlie Sheen and Bob Uecker as Harry Doyle, the movie was a big hit and spawned two sequels. The Stadium maintained its good looks for the Hollywood cameras, even though most of the baseball scenes were shot at County Stadium in Milwaukee. The Stadium later provided an authentic setting for the filming of *Babe Ruth*, starring Stephen Lang.

With the new ballpark at Gateway (later named Jacobs Field, now Progressive Field) to be ready for the 1994 season, the Indians prepared to play their final season in the old Stadium. While they were in spring training, tragedy struck the Indians family. On an off day, pitchers Tim Crews and Steve Olin were killed and Bob Ojeda was seriously injured in a boating accident. While manager Mike Hargrove's leadership was unquestioned, the Indians struggled through the final season at the Stadium and finished fifth with a 76-86 record.

On April 8, 1993, Indians second baseman Carlos Baerga became the first switch-hitter in major league history to homer from both sides of the plate in the same inning. Attracting more than 2,000,000 fans for the first time since 1949, 2,177,908 came to the Stadium to watch Tribe baseball

Before the Indians' final series, baseball fans were invited to "stroll" through Cleveland Stadium one last time. *Authors' collection.*

Commemorative tickets to the Indians' final series were sold in a block and imprinted, rather than torn, upon entry to each game against the White Sox. *Authors' collection.*

and relive the past. On September 30, an off day before the final series, fans were invited to the ballpark for a "Final Stroll." Visitors could walk through the dugouts, around the warning track and through the Stadium concourses. Many former broadcasters talked with fans, and many tears were shed.

The Indians sold tickets to the last series as a block of three tickets, and the series drew 216,904, including 72,390 for the last game. On Friday, October 1, in the final night game, Chicago won, 4–2. After the game, there was a ceremonial "shutting off" of the lights. The next afternoon, Chicago won another 4–2 game.

The final game on October 3 saw Charles Nagy start for Cleveland against Jason Bere. Bere threw seven shutout innings, and when Mark Lewis struck out in the ninth inning on a 2-2 pitch from Jose DeLeon, the White Sox sweep was completed with a 4–0 win. Chicago's Drew Denson got the last hit in the Stadium with an eighth-inning pinch single for the last of his ten major league hits in his final major league game.

After the game, closing ceremonies included introduction of many former Indians players. Bob Hope sang a modified version of "Thanks for the Memories." Mel Harder (who had thrown the first pitch at the new stadium

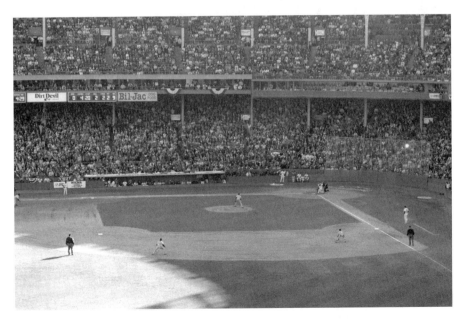

Jose DeLeon strikes out Mark Lewis with the last pitch at Cleveland Stadium on October 3, 1993. The White Sox beat the Indians 4–0. *Authors' collection.*

Since August 24, 1973, Tribe fan John Adams and his bass drum has been a fixture at Tribe home games. *Authors' collection.*

in 1932) threw a ceremonial "last pitch." Home plate was dug up and taken to the new ballpark.

Some fans took their time leaving the Stadium. John Adams banged his bass drum for a final farewell. For many fans, the new ballpark brought a new optimism, but for others the thought of leaving their old home was sad.

Even though the Indians were gone, the Browns still called the Stadium "home." After the Kardiac season, the Browns spent five years looking to recreate that success. Marty Schottenheimer replaced Rutigliano as head coach during the 1984 season. During training camp that year, cornerback Hanford Dixon, in an effort to spice up practices, started barking at his teammates on the line and calling them "Dawgs." Players, fans and the media ran with the nickname, and the Browns defense became "the Dawgs." Dixon and Frank Minnifield became the face of the dawg defense, and the

Sports Shrines from League Park to the Coliseum

Bernie Kosar quarterbacked the resurgent Browns to four division titles in his first five seasons. *Authors' collection.*

THE CLEVELAND BROWNS

bleacher end zone in the Stadium became the "Dawg Pound." Even after Dixon was gone, the Dawg Pound carried on and even moved to the new Cleveland Browns Stadium when it opened in 1999.

In 1985, the Browns drafted Bernie Kosar, who grew up near Youngstown and wanted to play for his hometown Browns. They finished 8-8 but still made the playoffs. The Browns gave Miami a scare in Florida, but a late fourth quarter touchdown gave the Dolphins a 24–21 win.

The next season, the team gelled and finished 12-4. They were on a roll into the playoffs. The sometimes overlooked first game was January 3, 1987, against the New York Jets at the Stadium. The favored Browns were stopped drive after drive by the Jets defense and trailed 20–10 with 4:14 to play after Freeman McNeil stormed twenty-five yards to the end zone. The quiet crowd was prepared for another disappointing loss.

Three plays into their possession, the Browns faced a second and twenty-four at their own seventeen, but as Kosar threw an incomplete pass he was drilled late by Mark Gastineau. The Browns had new life, and an energized Kosar drove them to a touchdown that cut the lead to 20–17. When the defense held the Jets, Cleveland got the ball back with less than a minute to

play. A penalty and a pass to Webster Slaughter set up a game-tying field goal by Mark Moseley that sent the game into overtime.

Early in the overtime period, Moseley missed a kick that would have won the game, and the teams battled for a scoreless fifteen minutes. Cleveland's defense was overwhelming, and in the second overtime Moseley redeemed himself with a game-winning twenty-seven-yard field goal. There would be another week of football after all.

The next week, on January 11, 1987, the Browns hosted the Denver Broncos in the AFC Championship game. By the end of the day, another heartbreaking loss, simply known as "The Drive," would torment the 79,915 in attendance and millions more who watched on television.

With a week to prepare and dreams of making their first trip to the Super Bowl, Cleveland was riding high. The Browns scored first on a Kosar pass to Herman Fontenot, but by halftime the game was tied, 10–10. Brian Brennan's forty-eight-yard touchdown reception gave the Browns a 20–13 lead in the fourth quarter. Fans and players alike felt that a trip to the Super Bowl was inevitable. Broncos quarterback John Elway felt differently.

Taking the ball at his own two-yard line with 5:32 to play, Elway started "The Drive" that culminated with Mark Jackson catching a five-yard touchdown pass with thirty-seven seconds left in regulation time. "The Drive" only tied the game, but it took the wind out of the Browns' (and their fans') sails. Cleveland won the coin toss in overtime but went three and out. John Elway quickly moved the Broncos into field goal range, and Rich Karlis barely made a thirty-three-yard field goal.

There was a deafening silence in the Stadium, but as the dejected Browns left the field, center Mike Babb recalls in *Classic Browns* by Jonathan Knight, "One guy started clapping. Then another guy started clapping. And then 100 people started clapping. And the next thing you know, the whole stadium… gave us this roaring, incredible standing ovation."

In 1988, the Browns defeated Indianapolis, 38–21, in a playoff game at the Stadium and headed to Denver for a rematch and another chance to go to the Super Bowl. When Earnest Byner fumbled the ball at the goal line, and Denver beat Cleveland again, 38–33, at Mile High Stadium, "The Fumble" took its place in Cleveland's list of near misses.

As the 1990s arrived, so did losing seasons and declining attendance. Bill Belichick was hired to coach in 1991. In the middle of the 1993 season, he released the popular Bernie Kosar, citing "diminishing skills," to the dismay of many Browns fans. In 1994, an 11-5 record propelled the Browns back to the playoffs, but the enthusiasm of the previous decade was missing.

Sports Shrines from League Park to the Coliseum

Nonetheless, 77,452 filled the Stadium on January 1, 1995, for an AFC Wild Card game between the Browns and the New England Patriots. A Vinny Testaverde touchdown pass, a Leroy Hoard touchdown run and two Matt Stover field goals gave Cleveland a 20–13 win in the final post-season game at the Stadium. The next week, in a first-ever playoff game between the Browns and Steelers, Pittsburgh trounced Cleveland, 29–9.

Many fans were jumping on the Indians bandwagon as they moved into their new home. With the Indians gone, the Stadium loges were not as attractive, and some business owners canceled their agreements. Additionally, many Stadium parking spaces were lost when the site was chosen to become the home for a new science center and the Rock and Roll Hall of Fame and Museum as part of a lakefront improvement plan.

On November 6, 1995, Art Modell announced that he was moving the Browns to Baltimore for the 1996 season due to financial considerations. Fans were furious. Advertisers pulled their ads, so there were plenty of empty boards at the Stadium in its final weeks. In the Browns' final game at Cleveland Municipal Stadium on December 17, 1995, the Browns beat the rival Cincinnati Bengals, 26–10. Just 55,875 attended.

Cleveland would not give up the Browns. Modell could take his team to Baltimore, but not the name, colors or the history. As part of the legal deal that set the stage for a new Cleveland Browns, the city was required to provide a new stadium. The decision was made to bulldoze the old stadium and build a new one at the same site.

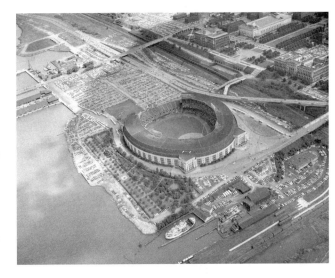

Cleveland Municipal Stadium dominated the lakefront landscape long before the Rock and Roll Hall of Fame and Great Lakes Science Center were built. *Courtesy the Cleveland Press Collection, Cleveland State University Special Collections.*

Where Cleveland Played

Above: Fans conducted their own preliminary demolition of the Stadium, tearing out seats and other pieces of memorabilia at the Browns' last home game in 1995. *Bill Bryan photo.*

Left: Preceding demolition of the Stadium, an auction of fixtures, equipment and other memorabilia took place in September 1996. Seats and bricks were sold separately. *Authors' collection.*

Sports Shrines from League Park to the Coliseum

This page and next: Four views of the destruction of Cleveland Stadium in 1997. *Bill Bryan photos.*

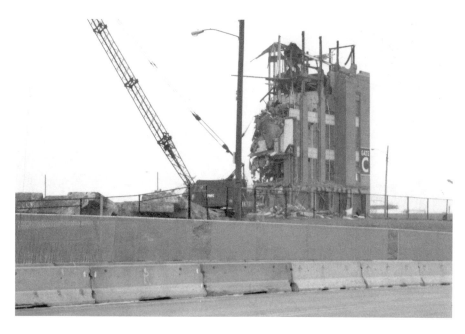

Sports Shrines from League Park to the Coliseum

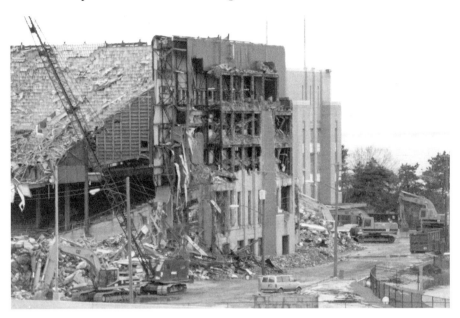

Cleveland Stadium's Gate E, bleachers and scoreboard are all in the process of being destroyed as the "Lady on the Lake" is demolished. *Bill Bryan photo.*

Gradually, activity at the Stadium ceased. "The Final Play" on September 21–22, 1996, gave fans one last chance to say goodbye to the "Lady on the Lake." An auction on September 24 further cleared out the building.

Bricks and seats were sold, steel and aluminum was recycled and more than ten thousand cubic yards of concrete were shoved into Lake Erie to create a fishing reef. In January 1997, Tower C fell and Cleveland Municipal Stadium was gone.

Conclusion

The buildings are all gone now, but they live in memories, books and artifacts. Everyone who ever followed the teams when they played in these homes have unique memories that can be passed along. Numerous books and publications about each sport keep the history alive. Internet sites continue to grow with stories and images.

There are many more people and events that make up the history of these places: the legendary Stadium and League Park groundskeepers Emil, Harold and Marshall Bossard; Stadium and Arena organist Walter J. Trimmer; Coliseum public address announcer Howie Chizek; announcer Tom Manning and his megaphone at League Park; Bertman's mustard; music shows at the Stadium, from the Beatles on August 14, 1966, to the Concert for the Rock and Roll Hall of Fame and Museum on September 2, 1995; dramatic boxing matches of Cleveland legends Jimmy Bivins and Joey Maxim at the Arena and the Stadium. There were barnstorming games in 1934 at League Park between Dizzy Dean's (white) all-stars and Satchel Paige's (black) all-stars and at the Stadium on October 1, 1946, when Paige's stars met Bob Feller's stars; the service game at League Park on September 28, 1921; Feller's eighteen-strikeout game against the Tigers on October 2, 1938, at the Stadium; the two Patriot games at the Stadium in 1942; Amateur Day at League Park and the Stadium; all of the wins in pursuit of championships; all of the games when records (big or small) were set; and all the games that are only important because you were there.

Conclusion

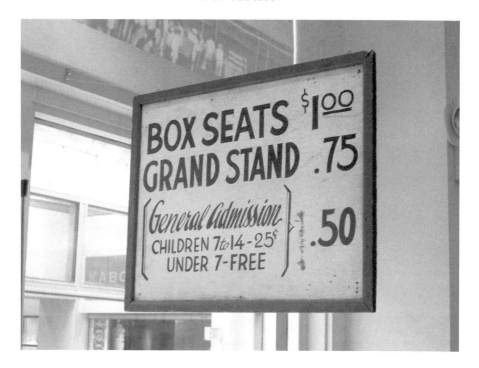

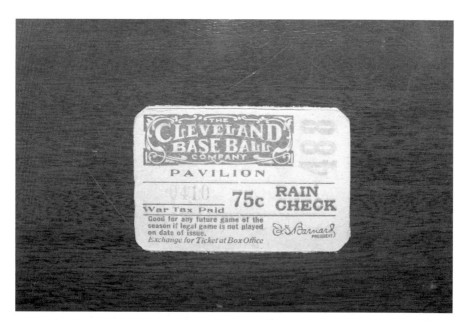

This page: Artifacts from Cleveland's old sports shrines are on display at museums, restaurants and other places. The ticket stub and sign from League Park are on display at the Baseball Heritage Museum in the Colonial Marketplace at 530 Euclid Avenue in downtown Cleveland. *Authors' collection.*

Conclusion

This page: Many fans have acquired artifacts (like the stadium seat, brick and ticket box from Cleveland Stadium) to keep alive fond memories of bygone Cleveland sports palaces. *Authors' collection.*

Conclusion

Many fans have collected tangible pieces from the shrines: seats, signs, turnstiles, bricks and other artifacts along with programs, ticket stubs, cups, pennants, bobblehead dolls, promotional giveaways and other souvenirs. Fans have also made their own memories by taking pictures, keeping score and getting autographs.

Observant fans will notice the Ray Chapman plaque at Heritage Park in Progressive Field, center circles from the basketball floors at Cleveland Arena and the Coliseum on display inside Quicken Loans Arena, the Chief Wahoo sign at Western Reserve Historical Society and League Park and Stadium artifacts at the Baseball Heritage Museum. A wide variety of other memorabilia and artifacts can be seen at local sports bars, restaurants and at other museums throughout the country.

Organizations like the Wahoo Club, Browns Backers, Rebounders Club and Cleveland Hockey Booster Club link generations and also keep memories alive while supporting current teams. Associations like the

This page and next: This Cleveland Browns ticket window and section sign from Municipal Stadium are examples of memorabilia in private collections that have survived the destruction of the building. *Authors' collection / Courtesy Dan Hartline.*

Conclusion

Society for American Baseball Research (SABR), Pro Football Researchers Association (PFRA), the Society for International Hockey Research (SIHR), the Association for Professional Basketball Research (APBR) and the International Boxing Research Organization (IBRO) preserve and disseminate the history.

Okay, Cleveland has not had a major sports champion since 1964. The histories of Cleveland Arena, the Coliseum, Cleveland Municipal Stadium and League Park remind us why Cleveland was the best location in the nation. Maybe the memories of past heroics will be a springboard to future success.

League Park is the exception. There is the hope of some special restoration to finally turn that hallowed ground into a thriving community centerpiece and historic destination. There is also the hope that Cleveland Arena, the Coliseum and Cleveland Municipal Stadium will be remembered and commemorated.

Bibliography

BOOKS

Benson, Michael. *Ballparks of North America*. Jefferson, NC: McFarland & Co., Inc. 1989.
Carroll, Bob, et al. *Total Football II*. New York: Harper Collins, 1999.
Clary, Jack. *Cleveland Browns*. New York: Macmillan Publishing, 1973.
Condon, George. *The Man in the Arena: The Life & Times of A.C. Sutphin*. Cleveland, OH: A.C. Sutphin Foundation, 1995.
Eckhouse, Morris. *Baseball Legends: Bob Feller*. New York: Chelsea House Publishers, 1990.
———. *Day by Day in Cleveland Browns History*. New York: Leisure Press, 1984.
———. *Day by Day in Cleveland Indians History*. New York: Leisure Press, 1983.
———. *Legends of the Tribe*. Dallas, TX: Taylor Publishing Company, 2000.
Eckhouse, Morris, ed. *All-Star Baseball in Cleveland*. Cleveland, OH: Society for American Baseball Research, 1997.
———. *Baseball in Cleveland*. Cleveland, OH: Society for American Baseball Research, 1990.
Gay, Timothy M. *Satch, Dizzy & Rapid Robert*. New York: Simon & Schuster, 2010.
Grabowski, John J. *Sports in Cleveland*. Bloomington: Indiana University Press, 1992.
Gray, Michael, and Roger Osborne. *The Elvis Atlas*. New York: Henry Holt, 1996.

BIBLIOGRAPHY

Greig, Murray. *Big Bucks & Blue Pucks*. Toronto: Macmillan Canada, 1997.

Haygood, Wil. *Sweet Thunder: The Life and Times of Sugar Ray Robinson*. New York: Alfred A. Knopf, 2009.

Honig, Donald. *The All-Star Game*. St. Louis, MO: The Sporting News, 1987.

Hudak, Timothy J. *The Charity Game*. Cleveland, OH: Sports Heritage Specialty Publications, 2002.

Jackson, John A. *Big Beat Heat: Alan Freed and the Early Years of Rock & Roll*. New York: Schirmer Books, 1991.

Jedick, Peter. *League Park*. Cleveland, OH: self-published, 1978.

Jones, David, ed. *Deadball Stars of the American League*. Dulles, VA: Potomac Books, 2006.

Kiczek, Gene. *Forgotten Glory: The Story of the Cleveland Barons*. Euclid, OH: Blue Line Publications, 1994.

———. *High Sticks and Hat Tricks: A History of Hockey in Cleveland*. Euclid, OH: Blue Line Publications, 1996.

Knight, Jonathan. *Classic Browns*. Kent, OH: Kent State University Press, 2008.

———. *Sundays in the Dawg Pound*. Kent, OH: Kent State University Press, 2006.

Levy, Bill. *Sam, Sipe & Company*. Cleveland, OH: J.T. Zubal & P.D. Dole, 1981.

Lowry, Philip J. *Green Cathedrals*. New York: Walker & Company, 2006.

Menzer, Joe, and Burt Graeff. *CAVS from Fitch to Fratello*. Champaign, IL: Sagamore Publishing, 1994.

Mirlis, Eric. *Being There*. Guilford, CT: Lyons Press, 2007.

Nadel, Eric. *Texas Rangers*. Dallas, TX: Taylor Publishing Co., 1997.

Phillips, John. *The Crybaby Indians of 1940*. Cabin John, MD: Capital Publishing Co., 1990.

Poplar, Michael G., with James A. Toman. *Fumble! The Browns, Modell and the Move*. Cleveland, OH: Cleveland Landmark Press, Inc., 1997.

Reidenbaugh, Lowell. *Take Me Out to the Ball Park*. St. Louis, MO: Sporting News Publishing Co., 1983.

Ritter, Lawrence S. *Lost Ballparks*. New York: Viking Penguin, 1992.

Schneider, Russell. *The Cleveland Indians Encyclopedia*. 3rd edition. N.p.: Sports Publishing L.L.C., 2004.

Sowell, Mike. *The Pitch That Killed*. New York: Macmillan Publishing Company, 1989.

Bibliography

Sullivan, Brad, ed. *Batting Four Thousand*. Cleveland, OH: Society for American Baseball Research, 2008.

Toman, James A., and Gregory G. Deegan. *Cleveland Stadium: The Last Chapter*. Cleveland, OH: Cleveland Landmarks Press, 1997.

Trexler, Phil. *Cleveland Indians Yesterday & Today*. Lincolnwood, IL: Publications International Ltd., 2009.

Veeck, Bill, and Ed Linn. *Veeck—As in Wreck*. New York: Bantam Books, 1962.

Willes, Ed. *The Rebel League*. Toronto: McClelland & Stewart, 2004.

Newspapers

Akron Beacon-Journal
Cleveland News
Cleveland Plain Dealer
Cleveland Press

Team Publications

Cleveland Arena game programs.
Cleveland Barons game programs.
Cleveland Browns media guides.
Cleveland Cavaliers game programs and media guides.
Cleveland Crusaders game programs and media guides.
Cleveland Force media guides.
Cleveland Indians game programs and media guides.

Videos

Bacon, Mike. *Records in the Sand*. Classic Teleproductions, Cleveland, Ohio, 1995.

Websites

Baseball-Reference.com. http://baseball-reference.com.
Boxing Records. http://boxrec.com.

Bibliography

The Cleveland Memory Project. http://www.clevelandmemory.org.
The Encyclopedia of Cleveland History. http://ech.cwru.edu
Hockey-Reference.com. http://www.hockey-reference.com.
NBA & ABA Basketball Statistics & History. http://basketball-reference.com.
1919 Black Sox.com. http://www.1919blacksox.com
Pro Football Hall of Fame. http://www.profootballhof.com.

About the Authors

Morris Eckhouse is the creator of the Magical Baseball History Tour (MBHT), a partner in October Productions, and author or co-author of seven books. He was executive director of the Society for American Baseball Research (SABR) and the Cleveland Sports Legends Foundation. A member of the American Association of Museums (AAM), SABR, the International Sports Heritage Association (ISHA), the Society to Preserve and Encourage Radio Drama (Sperdvac) and the National Historic Route 66 Federation, Eckhouse is a 1978 graduate of Shaker Heights High School and a 1982 graduate of Ohio University. He and his wife, Maria, live in Shaker Heights. Their son, Allen, is a student at the University of Southern California. Visit the Magical Baseball History Tour at www.magicalbaseball.com.

About the Authors

Greg Crouse is an accountant who became a sports fan as a kid in the early 1970s. He has attended hundreds of events at Cleveland Stadium, the Coliseum and Cleveland Arena and has visited the League Park site many times since the late 1980s. He has been a member of the Society for American Baseball Research (SABR) since 1983 and has been published in SABR's *Baseball Research Journal*. Greg is a 1982 graduate of the University of Akron. He lives in Cuyahoga Falls, Ohio.